IMAGES
of America

SILVERDALE

ON THE COVER: WASHINGTON COOPERATIVE EGG AND POULTRY ASSOCIATION. Farmers' cooperatives have been a part of Silverdale since 1887. Farmers in the burgeoning egg and poultry business found they could get better prices for their eggs and pay less for supplies by banding together to form cooperatives. Here, members and employees display association-procured feed on the loading dock, and, in the right foreground, crates of eggs to be sold at markets in Seattle and elsewhere, including as far away as Chicago. Between 1943 and 1948, the cooperative had six to eight people candling eggs, one of whom was Ed Singer. George Porter and Oliver Hagener delivered oil, Kenny Frye and Ed Hanson were warehousemen, Palmer Peterson was the manager, Ben Judge was a driver, Agnes Allpress was bookkeeper, and Juanita Hanson and Cora Herndon worked in the office. The other employees included Gilbert and Jack Hutchings and Bert Sibon. (Courtesy Kitsap County Historical Society.)

IMAGES
of America

SILVERDALE

Kitsap County Historical Society

ARCADIA
PUBLISHING

Copyright © 2014 by Kitsap County Historical Society
ISBN 978-1-4671-3013-4

Published by Arcadia Publishing
Charleston, South Carolina

Printed in the United States of America

Library of Congress Control Number: 2013932585

For all general information, please contact Arcadia Publishing:
Telephone 843-853-2070
Fax 843-853-0044
E-mail sales@arcadiapublishing.com
For customer service and orders:
Toll-Free 1-888-313-2665

Visit us on the Internet at www.arcadiapublishing.com

To Tom Haynes,
editor of the Silverdale Breeze *from 1928 to 1937,*
a one-man chamber of commerce who called
Silverdale a "diamond in an emerald setting."

CONTENTS

ACKNOWLEDGMENTS

The Kitsap County Historical Society extends heartfelt gratitude to the following for making the project possible: the society's board of trustees for support and sponsorship; executive director Patricia Drolett for leadership and guidance; Claudia Hunt, Randy Hunt, and Carolyn Neal for selecting images and writing text; Nina Hallett for editing; Eric Dahlberg for technical assistance; George Willock for guidance and support; and Carolyn LaFountaine for locating images no one else could find. The society also thanks the following individuals for sharing photographs and stories that helped to fill in the gaps: Jim Bob Armstrong, Chris McCoard Anderson, Jean Balter, Burt Boyd, John Challman, Harold and Mary Lou Dahl, Gloria Vig Edwards, Darrel and Wendy Emel, Barbara Bartlett Flieder, Leonard Forsman, Dave Gillette, Randi Dahl Gjerstad, Lawrence Greaves, Paul Harshbarger, Marlene Brooks Hattrick, Norma Sprague Holm, Marvel Hunt, Nikki Johanson, Joan Guilford Kaiser, Dale Eric Kegley, Betty Koster, Judy Morgan, Alan Paulson, Sophia St.Clair Peterson, Webb Rhodes, Jack and Carrie Riplinger, Dean Schold, Cindy Berry Starkenburg, Frank Stottlemeyer, Bonnie and Cordell Sunkel, and Don Vaughn. Unless otherwise noted, all images in this book are provided courtesy of the Kitsap County Historical Society.

INTRODUCTION

The commercial center of Kitsap County is at the head of Dyes Inlet, an extension of the inland sea known as Puget Sound. The county itself occupies 395 square miles of the Kitsap Peninsula, which is located eight miles east of Seattle and is divided into the general geographic areas of North, South, and Central Kitsap, plus the cities of Bremerton and Bainbridge Island. Although it is unincorporated, Silverdale represents the most populous part of the county and serves as the hub of the Central Kitsap region.

The earliest known native inhabitants of the inlet were a band of about 200 members from several Puget Sound tribes. Puget Sound teemed with salmon and other saltwater fish, while the shorelines provided a bounty of shellfish. Dense forests extending to the water's edge were a source of game, a variety of native berries and edible plants, and the mainstay of Pacific Northwest Native American culture—cedar trees. The trees were used to make shelters, transportation (in the form of dugout canoes), clothing, mats, tools, and cooking implements. The Dyes Inlet natives were not a sedentary people; they followed fish runs and plant harvests, moving their traditional campsites from winter locations to summer ones and occasionally moving to avoid conflict with raiding tribal parties from the far north.

British explorer George Vancouver sailed into the great inland sea in 1792 and named it Puget's Sound after his lieutenant Peter Puget. Vancouver also named many other places in the area. Charles Wilkes, commander of the 1841 US Exploring Expedition, also sailed into this area. Wilkes named Dyes Inlet in honor of John W.W. Dyes, assistant taxidermist with the expedition.

The first nonnative settler to arrive on the shores of Dyes Inlet was an Englishman, William Littlewood, a logger, who hit land sometime after 1850. Silverdale was developed by a hardy breed of men using oxen (later horses) to haul enormous trees out of the forests, down to the water, and off to the mills. Timber harvesting was a lucrative business, and the hardy men created a thriving forest-based economy. Logged land was considered worthless, at least as far as the loggers were concerned. However, in clearing the land, they were creating landscapes suitable for the next group of settlers.

Attracted by the promise of free land under the Donation Land Act of 1850 and the Homestead Act of 1862, Americans, Swedes, Norwegians, and other European immigrants established homesteads throughout the Kitsap Peninsula. In 1857, Washington Territory officially recognized the area as a new county, and the legislature decreed it be named Slaughter to honor the death of Lt. William Slaughter in the Indian Wars. Six months later, a countywide vote changed the name to Kitsap.

By the late 1880s, there were enough residents on Dyes Inlet to generate the need for a postal address. The first name considered was Dickeyville, to honor Silvanus Dickey, an educator, businessman, and prominent figure in the area. Then the name Goldendale was selected in hopes of ensuring a golden future for the community. After authorities in the territorial capital, Olympia, noted that Goldendale had been chosen by another town just a few weeks earlier, local settlers

downgraded the name to Silverdale in 1890. It is often erroneously assumed that there was some sort of literal silver in Silverdale's past, but there never was a silver mine in the area.

What the community did have was a bounty of agriculture and an easy means of transportation to the markets of Seattle. Everything from berries to dairy products traversed Puget Sound aboard the myriad of small steamers collectively known as the Mosquito Fleet. Not only did these small vessels transport people and cargo, they also carried mail and newspapers and sometimes served banking needs. They connected Puget Sound communities to each other and also to the outside world. Silverdale probably would not have existed if not for its access to the waters of Puget Sound.

Silverdale farmers created an extensive poultry industry, in part due to the difficulty of removing the large stumps left behind by the loggers. Crops required open spaces suitable for plowing, but chickens were unhindered by stumps that would otherwise need to be removed. Silverdale was an early leader in the cooperative movement, starting with the Farmers' Union, which evolved into the Silverdale Poultry Association—a group that sold eggs to outlets across the country. Silverdale still retains some of its agricultural traditions. Local farmers sell organic produce at the farmer's market, and residents generally support community efforts to preserve the area's remaining farmlands and protect them from encroaching urbanization.

World War II marked a turning point in Silverdale's history. The massive defense effort, which made nearby Bremerton the fourth-largest city in Washington, spilled over into Silverdale. Structures that had once housed chickens were rented out as homes for defense workers. Army units encamped on Silverdale's schoolyards, manning the barrage balloons and antiaircraft guns that defended the Navy Yard Puget Sound from possible attacks. Silverdale's Clear Creek Valley offered a straight flight path into Bremerton, and the shipyard—and therefore Silverdale—became an important part of the defense system. Local residents volunteered for shifts spent watching the skies for approaching planes.

Silverdale continued to play a role in the nation's defense after the war ended. The US Navy's decision to locate a Trident submarine base on the shores of Hood Canal, just northwest of Silverdale, ushered in the town's third era of prosperity. The infrastructure needed to support the naval base created a new Silverdale as highways, schools, housing, and sewers served the major influx of military families that converged on the town. The growth attracted new businesses and led to a proliferation of malls and shopping centers. The crossroads of Silverdale became a retail center for the entire Kitsap Peninsula and also the greater Olympic Peninsula.

Despite acres of additional paved parking lots and hillsides covered with apartment buildings, condominiums, and houses—plus an economy now based on consumption rather than production— Silverdale has not lost touch with its heritage. The original townsite, or Old Town, preserves its character along with some of its historic buildings. The waterfront, which was once so important to the area's economy, is now equally important for its recreational value and serves as a venue for the town's major summer festival, Whaling Days. Clear Creek, a stream that flows through the valley and empties into Dyes Inlet, was once important to agriculture. Through the efforts of volunteers, it has been saved for recreational use and also serves as a critical salmon habitat.

For more than 100 years, Silverdale has continued to develop and move forward while firmly maintaining the sense of community that grew up along the shores of Dyes Inlet.

One

OLD TOWN

1857–1920

Silverdale is a community shaped by a combination of geography and a succession of settlers drawn to the area for various reasons. The waterside location made the area easily accessible and provided an impetus for commercial activities.

The first people known to live on the shores of Dyes Inlet were Native Americans occupying the area now known as Erland's Point, just south of the current Silverdale. Residents of the village were a common sight in early Silverdale. Traveling by canoe, they would arrive on the town's waterfront and purchase goods from the stores located there. The village eventually became the community of Chico, named after Chief William Chico. Another prominent member of the tribe, Steve Wilson, was instrumental in establishing a Catholic church and cemetery at the Erland's Point site. An area legend claims that Wilson supposedly buried a stash of gold in a teapot somewhere under a tree on Erland's Point.

Dense forestland on the Kitsap Peninsula, accompanied by an insatiable demand for lumber, gave the area its first primary industry—logging. As the land was cleared, starting from the shoreline and moving inland, loggers were joined by a new group of settlers who had come to Silverdale to farm. These new arrivals were often immigrants from northern European countries who were drawn by the lure of free land under the federal Homestead Act of 1862. Any adult intending to become a citizen could claim up to 160 acres of public land by paying a small fee and living on the land, while making improvements, over a period of five years. Homesteaders also had the choice of purchasing their land for $1.25 per acre after only six months of residency.

By the 1890s, Silverdale had developed the commercial infrastructure to serve the growing population of homesteaders. The construction of the first store and post office was quickly followed by that of a hotel, livery, and other businesses. The forging of a real community proceeded with the building of churches and schools, providing the basis for a more vibrant social scene that supported clubs, athletics, and group outings.

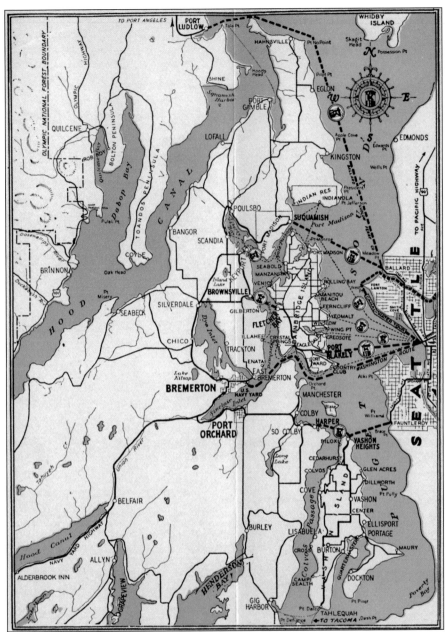

MOSQUITO FLEET ROUTE MAP, 1920s. The central area of this county map shows the settlements of Chico, Tracyton, Silverdale, and Bangor. They, along with the smaller settled areas of Port Washington, Erland's Point, Fairview, Central Valley, Clear Creek Valley, Island Lake, Olympic View, Anderson's Landing, and Lone Rock, are what was considered Central Kitsap at that time. There were very few paved highways in the county. The most important one was the Navy Yard Highway, which connected the Navy Yard Puget Sound at Bremerton with Mason County and ran southward to the state capital, Olympia. Most other roads were unpaved and often difficult to negotiate in winter, with travel out of the area usually done by ferry boat. The dotted lines across Puget Sound represent some of the independently owned and competing Mosquito Fleet Ferry routes.

CATHOLIC CHURCH ON ERLAND'S POINT, C. 1914.
Known as Our Lady of Good Counsel Indian
Church, this building featured a bronze steeple
bell and interior cabinetry made by local Native
Americans. After much controversy within the
tribe, the church was built using earnings from the
tribe's dogfish oil industry. Services were conducted
by visiting priests from the Tulalip Reservation
or by Chief William Chico or Steve Wilson.

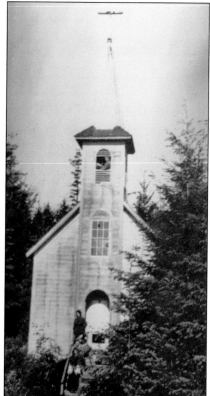

DUGOUT CANOE, C. 1895. Native Americans
Steve Wilson and his wife, Mary Hinckley,
are pictured here in their canoe. Wilson was a
prominent member of the group of around 200
Indians living on Dyes Inlet at Steve's Point,
which is now part of Erland's Point. To protect
their land, Wilson and Chief William Chico
renounced tribal relations, became citizens,
and filed homestead claims across 160 acres.

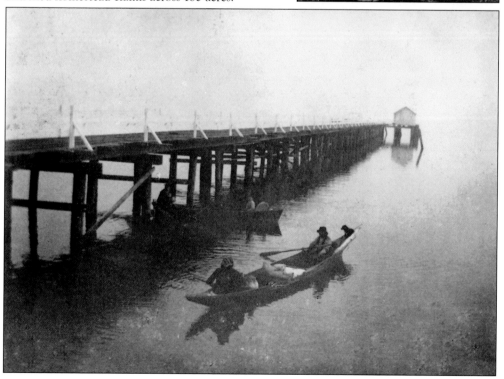

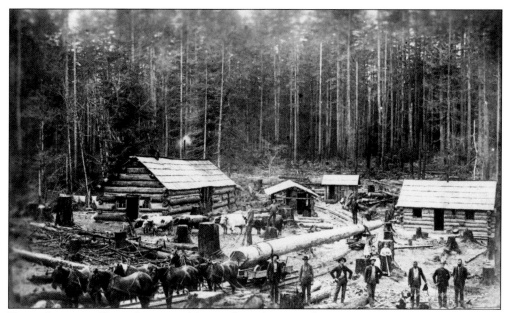

EARLY LOGGING CAMP. Logging old-growth timber was the major economic activity around Silverdale. In this image, a team of horses pulls a log along a narrow gauge railroad track rather than the usual skid road of logs. Homesteader Thor Gilbert, for whom the nearby community of Gilberton is named, is at far right. Second from right is teenaged Eric Forsberg, a logger who appears in all photographs of Thor Gilbert.

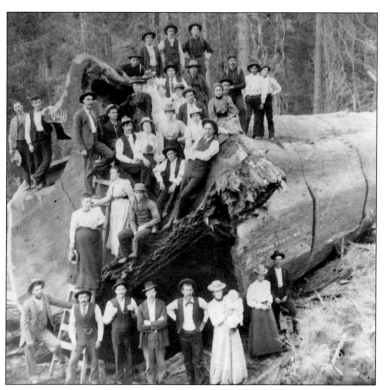

ADMIRAL DEWEY. This group of July 4th revelers is celebrating by posing around a tree that was named for the hero of the Battle of Manila Bay, which took place during the Spanish-American War. Even in the late 1890s and early 1900s, this 21-foot-diameter virgin tree would be considered a record-setter.

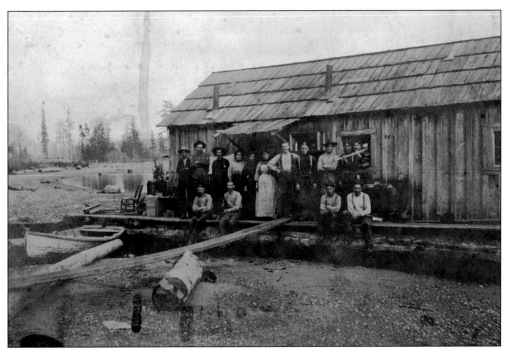

SACKMAN'S FLOATING BUNKHOUSE, C. 1910. Since most of the early logging in Kitsap County was along about 200 miles of Puget Sound shore, a floating bunkhouse was an easy way to create a temporary logging camp. When logging operations were finished, the bunkhouse could be towed to the next site.

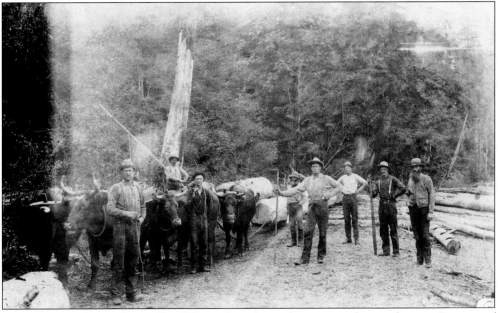

LOGGING WITH OXEN. Originally, all Puget Sound–area logging was done with oxen. Oxteams of up to six yokes hauled the logs out of the woods on a skid road. These roads were made by stripping the bark from smaller logs, laying them out crosswise, and oiling them with dogfish oil. Logs were dragged along the skids to the shore, then rolled into the water and floated to market.

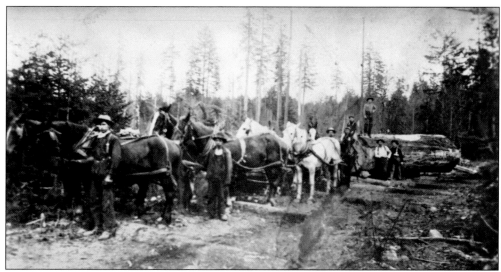

B.F. AND W.H. TAYLOR TEAMSTERS, TRACYTON. When new technologies were introduced (such as changes in the attachment of harnesses), the skidding of logs became more efficient. Loggers eventually replaced oxen with horses, substituting the power of the ox for the ease of handling horses. Owners of teams of horses would hire them out to logging companies.

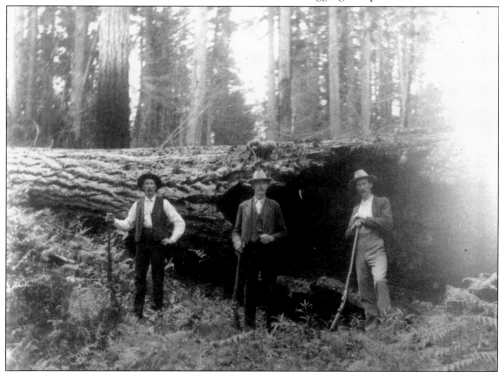

PETER (LEFT), JOHN (CENTER), AND GILBERT PAULSON. The Paulson brothers are pictured here on their property. John arrived in Central Valley in 1886 and homesteaded 120 acres in 1888. He came from Norway via Cape Horn in a sailboat, first landing in Hawaii. In 1915, John donated the land for the community hall located on Central Valley Road; the hall is now run by the Central Valley Garden Club. (Courtesy Alan Paulson.)

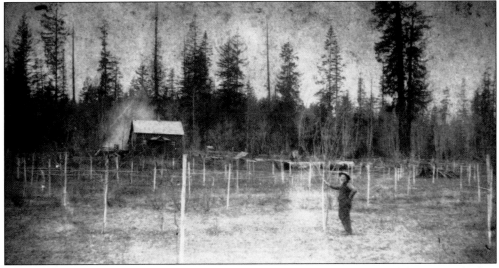

HOMESTEAD CERTIFICATE. The Homestead Act of 1862 allowed early settlers to claim 160 acres provided they live on the property for five years and show they had made improvements such as building a house and clearing land. This was known as proving up a claim. This homestead certificate for Thor Guldbranson (later changed to Gilbert), dated March 8, 1895, bears the signature of Pres. Grover Cleveland.

WILLIAM LITTLEWOOD. Littlewood was the first recorded settler in the Silverdale area. In the late 1850s, before moving to the Silverdale area, he logged near Seabeck and the surrounding areas. For a time, he held the government contract to maintain the 15 miles of trail from Manette Point, in east Bremerton, to Seabeck on Hood Canal. In 1888, he built a cabin near the current location of Linder Baseball Field in Silverdale.

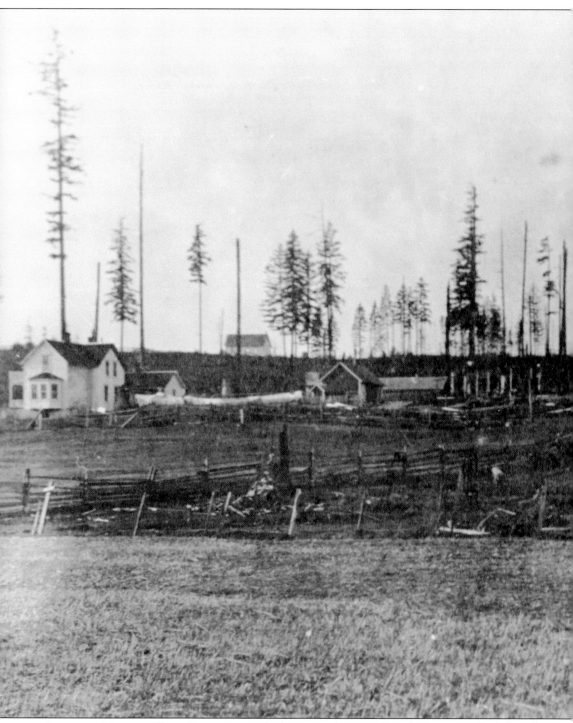

JOHN AND MATILDA HOLM HOMESTEAD. The barn at right, as well as the house on the left, still stand today on the property known as the Petersen Farm, the last large agricultural property in the area, which is located at the east end of Trigger Avenue. The small white building on the ridge in the left background was the first church in the valley; it is now Silverdale Grange. In

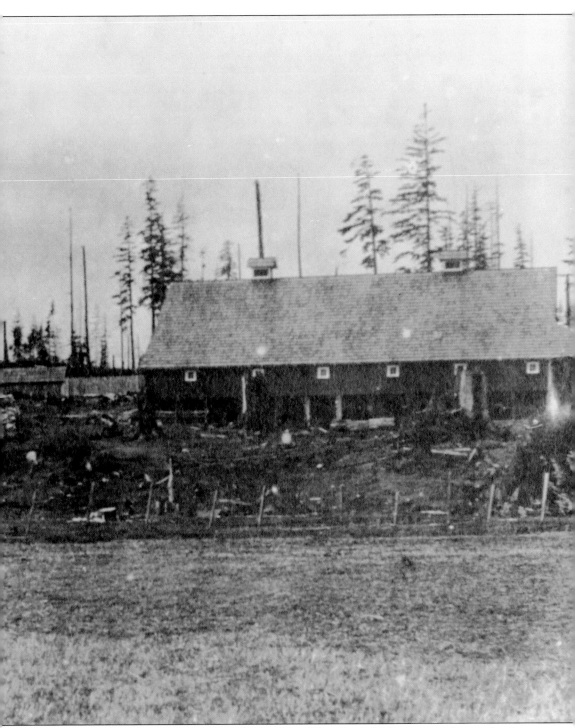

1895, John Holm, along with many residents of the Clear Creek Valley, gave eight-year logging rights to I.N. Sill and R. Evans. This enabled John to become a leader in the valley by, in 1904, building a barn suitable for running a dairy as well as handling all the other functions of an independent agricultural company.

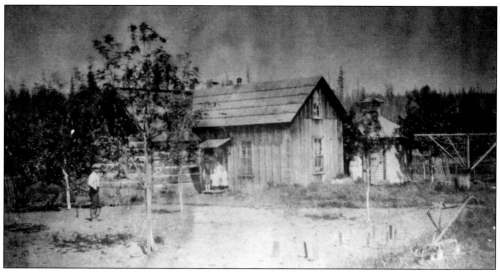

ANDREW JOHN SCHOLD FAMILY. Swedish emigrant Andrew John Schold arrived in Clear Creek Valley in 1884 and filed for a 160-acre homestead where he and his wife, Hanna, established a large farm and raised eight children. Hanna is credited with naming Clear Creek based on its clarity. In the 1907 photograph below, members of the Schold family pose on an ornate quilt in their Sunday finery while holding musical instruments. Pictured are, from left to right, (first row) Andrew, Leonard, Hanna, Clarence, Arthur, and Alma; (second row) Albin, Mabel, Edith, and Esther.

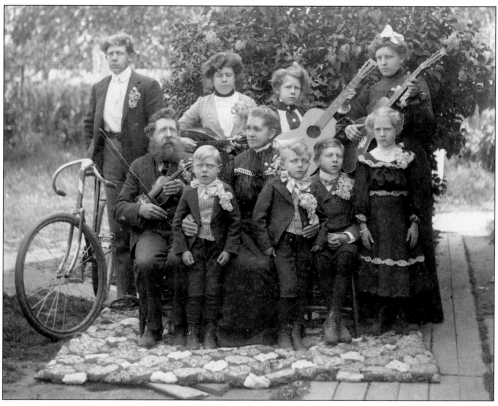

JOHN AND MATILDA HOLM HOME. This residence predates the 1904 barn. John and Matilda had seven children—Ella, Hilda, Walter, Alfred, Jennie, Sigurd (who married Pete Hilstad), and Ruth. It is unknown which of the children are pictured with John and Matilda. When John died in 1907, the farm came into the hands of his in-laws, the Hilstads, and became the Meadowlark Dairy before being sold to Gerald and Dorothy Petersen in 1948.

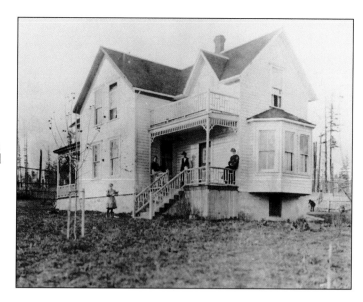

JOHN AND JULIA LEVIN HOME. John arrived from Sweden in 1883, became a citizen by 1890, obtained a homestead patent, and built a catalog-kit log cabin for his Norwegian bride, Julia Torske. John died in 1919, and Julia lived in this home without electricity into the early 1950s, despite family urgings to install utilities. This home is now part of the Petersen Farm on Trigger Avenue. (Courtesy Nadean Ross.)

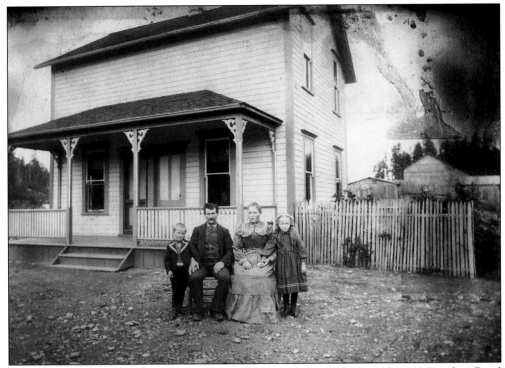

ST. CLAIR HOMESTEAD. In 1886, Columbus St. Clair homesteaded on Anderson's Landing Road (Anderson Hill Road), east of the present-day location of Apex Airpark. Columbus married Sophie Mast in 1894 and built a new house to replace the homestead's original cabin. The St. Clairs are pictured here with their two children, Rennie and Esther, in 1899. The family raised dairy cows and chickens, trading them for staples at the boat landing in Silverdale.

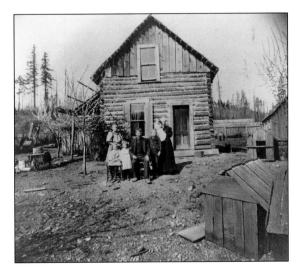

THOMAS HAGENER. Ohio native Hagener and Columbus St. Clair logged together before establishing adjacent homesteads in 1886. A coin toss determined St. Clair's property to be closest to the road, but by 1906 Anderson Landing Road was relocated, benefiting Hagener's property also. Hagener ran a dairy farm and, in 1887, helped start the first farmers' cooperative in Silverdale. Pictured are, from left to right, (standing) daughter Amy, son Oliver, and Thomas's mother Barbara (holding Evelyn); (seated) daughters Edna and Ethel, and Thomas. Emma, his wife, died in 1907.

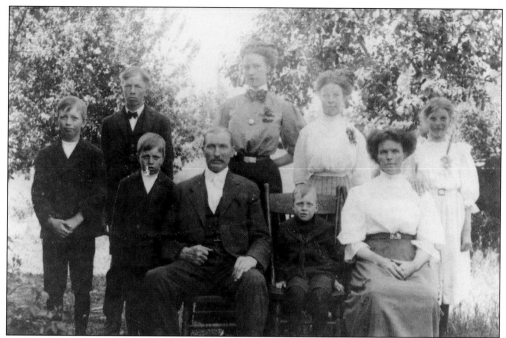

JOHN PAULSON FAMILY. Norwegian-born John Paulson arrived in Central Valley in 1886, establishing his homestead in 1888 at what is now the southeast corner of Central Valley and Paulson Roads. Pictured are, from left to right, (first row) Theodore, John, Henry, and Tilla Marie; (second row) William, Arthur, Marie Sophie, Anna Catherine, and Jennie. (Courtesy Alan Paulson.)

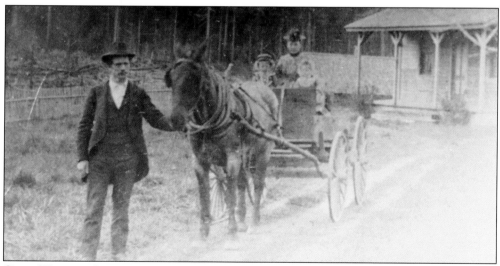

CLAIS WILHELM GUSTAFSON FAMILY. Swedish immigrant Clais Wilhelm (aka C.W.) Gustafson established a homestead on the west side of the Clear Creek Valley in 1889. He met Lina Johnson in 1894, and they married in 1895. C.W. cleared the property himself and built the house and barn shown in this 1903 image. C.W. is leading the horse with Lina and their two children, Helen and Agnes, in the wagon. Lina died in 1904 during childbirth.

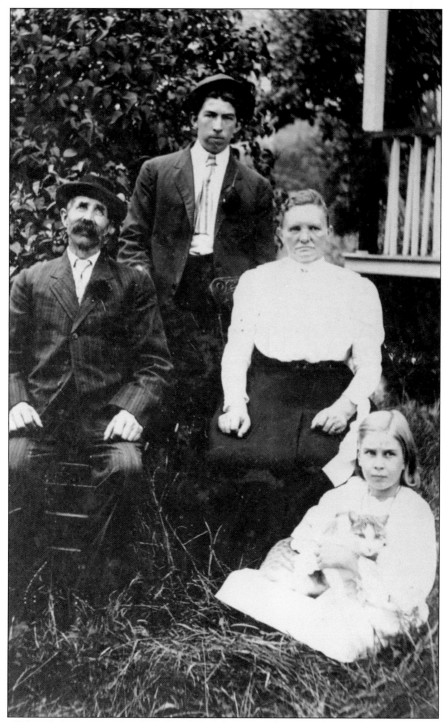

CHRIS "MULE" ANDERSON. In 1887, Swedish fisherman Chris "Mule" Anderson was lured from Plattsmouth, Nebraska, to the Clear Creek Valley by the Homestead Act of 1862. Pictured are, from left to right, Chris; his son Ernest David; his wife, Augusta; and their foster daughter Loula Baker (holding Yonkers the cat).

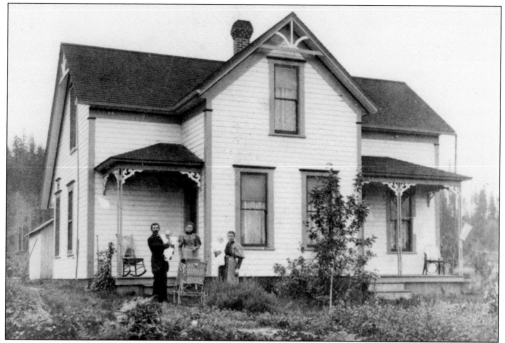

WILLIAM SCHOLD FAMILY. William Schold arrived in 1891 and farmed in the Clear Creek Valley on 80 acres of his brother Andrew's property. In 1892, William married Emma Johnson, sister of Andrew's wife, Hanna. William built this house from lumber rafted from the Port Madison mill on Bainbridge Island. William and Emma had twins, and in this 1897 photograph, William is holding Lawrence while Emma holds Nettie; they are pictured with their niece Esther Schold.

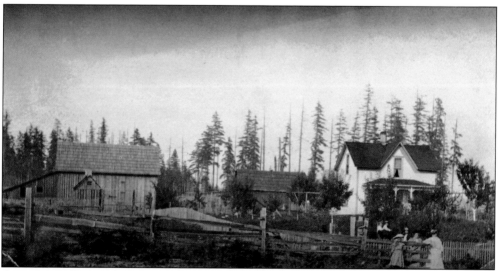

ALBERT AND CHRISTINA JOHNSON FARM, C. 1904. The Johnsons arrived in Clear Creek Valley in 1891, buying 40 acres from Albert's brother, Jonas. Albert logged while establishing a poultry farm. The brothers built a connection to the main road and bridged the creek. Albert and Christina provided land for the Swedish Free Mission Church (built in 1903) and the second Clear Creek School (1908) before selling the farm in 1943 and moving into Silverdale.

GREAVES FARM. Charles and Edith Greaves arrived in 1894, purchasing 40 acres (now the Kitsap Mall site) and, later, another 10 acres. Charles, trained in veterinary medicine, tended to neighbors' livestock and set neighbors' broken bones. He also kept Holstein cows and helped organize the first farmers' cooperative. A founder of the Silverdale State Bank in 1919, he was its president for 18 years. His son and grandson also served as directors of the bank.

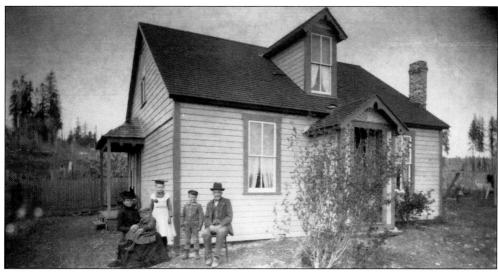

JONATHON MILL FAMILY. English immigrant Jonathon Mill arrived in 1899 and filed an 80-acre homestead on what is now Newberry Hill Road. He cleared land, built a cabin, planted fruit trees, and raised chickens. In 1891, he married Zorada Benoy on the beach in front of William Tell Gaffner's store. The couple bought five acres in Silverdale and moved into this new two-bedroom home. Pictured in this c. 1900 photograph are, from left to right, Zorada, children William, Eliza Jane, and Vernon, and Jonathon.

24

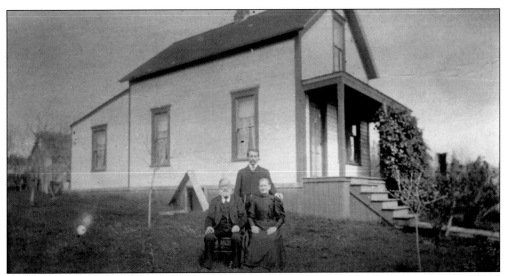

JONAS AND BRETTA EDEN. The Edens, along with their son John (standing in back), emigrated from Sweden to the United States in 1902. They bought Mads and Lena Thuesen's original house and store across from Yeoman's Hall on Washington Street. By 1910, Bretta was a widow taking in boarders, and 34-year-old John was working as a waiter in a café.

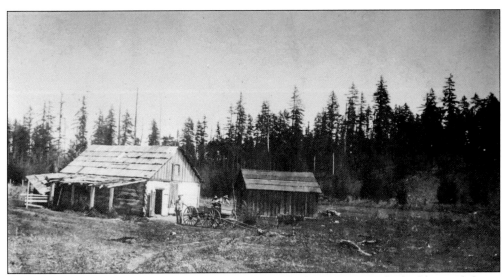

GEORGE F. SCHUBERT HOME, 1910. Originally part of a logging camp, the building at left was used as a barn until the new one was built. The family's horse was tall, and the horse collar's hames rubbed against the top of the doorway. George's daughter Frieda Walworth said, "Imagine my father's consternation when I landed just inside the door with a bloody forehead! My dad was a thinker while leading a horse."

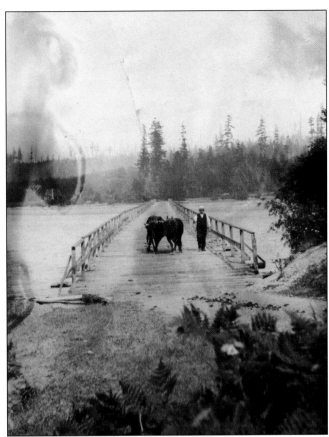

PETER FRANK EMEL. In the image at left, Emel is shown driving his prized oxen Nig and Dick across Big Beef Bridge sometime before 1916, when the bridge was replaced by a larger one. The oxen are leaning against each other because they were afraid of the cracks between the boards. When Emel proposed building bridges over Big and Little Beef Creeks, his neighbors guffawed because nothing but a narrow footpath connected Seabeck to the rest of the county. Emel won the contract by convincing county commissioners that if a bridge were built there, a road would follow. Little Beef Bridge was 330 feet long, while Big Beef was slightly over 800 feet long. Little Beef Bridge was completed on July 4, 1896, and Big Beef Bridge was started immediately after. (Both, courtesy Darrel Emel.)

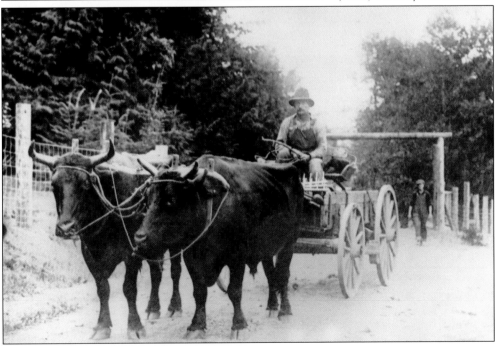

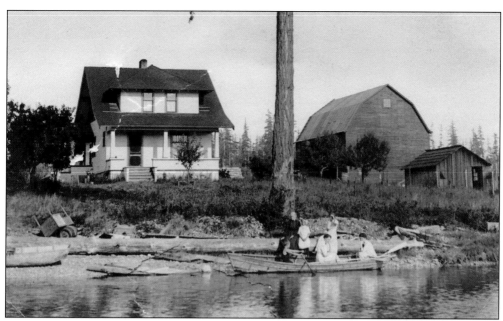

MARCUS AND BERNICE BARTLETT HOME, 1910. In the boat are the Bartlett children Herbert, Georgia, and Otis. Siblings Jannette Jo and Bernice are on either side of Helen, Otis's wife. The Bartletts' seven acres was located on the east side of Clear Creek, straddling Bucklin Hill Road, which now includes the Christa Shores Retirement Center area. Unofficially called Bartlettville, it had five homes housing Marcus and Bernice and their children. (Courtesy Barbara Bartlett Flieder.)

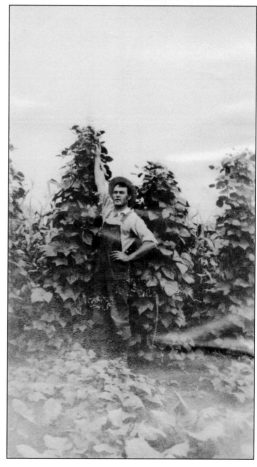

OTIS AND THE BEANSTALK. Otis and Helen Bartlett raised chickens, cows, and a market garden on their seven-and-a-half-acre farm, selling produce, chickens, bread, and head cheese (a jellied loaf or sausage made from the edible parts of a pig's head and feet) at the farmer's market in Bremerton for 45 years. They raised their five children—Max, Rex, Hal, Betty, and Tom—with no other outside source of income. (Courtesy Barbara Bartlett Flieder.)

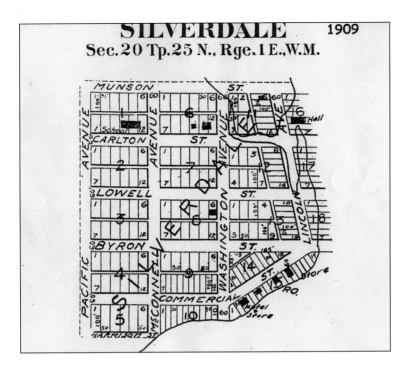

SILVERDALE 1909
Sec. 20 Tp. 25 N., Rge. 1 E., W.M.

OLD TOWN SILVERDALE PLAT MAP, 1909. Herod Wells received the original platted area from the government in 1870 and allowed Louis Gardner and Daniel Sackman to harvest the area timber. In 1888, Alexander A. Munson granted the right to clear, plat, and record the Silverdale townsite to William Bremer and J.K. McConnell.

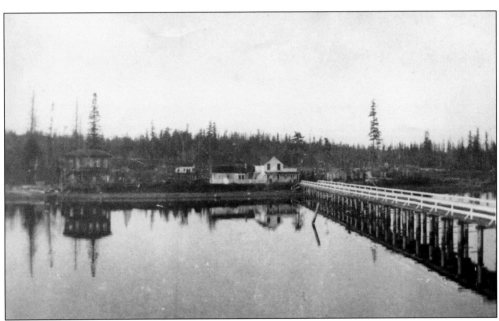

SILVERDALE WATERFRONT, 1893. In 1889, William Tell Gaffner built a store and post office along Commercial Street, at the end of the wharf, then constructed this wharf in 1890. After 1896, the store became the Silverdale Hotel. The original cooperative building (at left) was constructed in 1891 but became successively the Challman Hotel, the Walker Hotel, Mrs. Linn's General Store, and the Linn Hotel. The original schoolhouse is between the two hotel buildings.

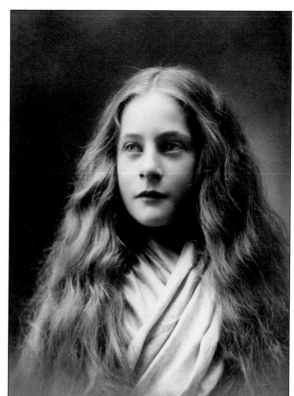

DELLA S. GAFFNER, 1895. Della, the only child of William Tell and Tillie Gaffner, owners of Silverdale's store and post office, was five years old in 1895, when she received the Christmas gifts pictured below. The dolls in the buggy have china heads, hands, and feet and sawdust-filled bodies. The large doll was quite lifelike: her eyes would open and close and her joints moved. Della became an accomplished landscape painter.

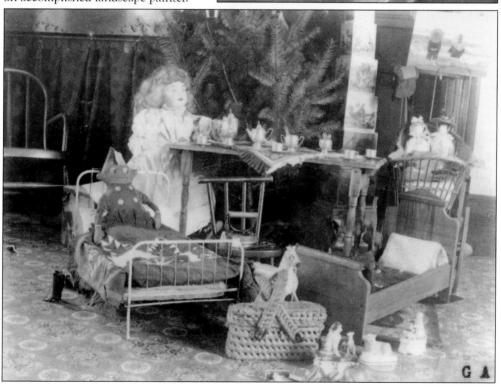

29

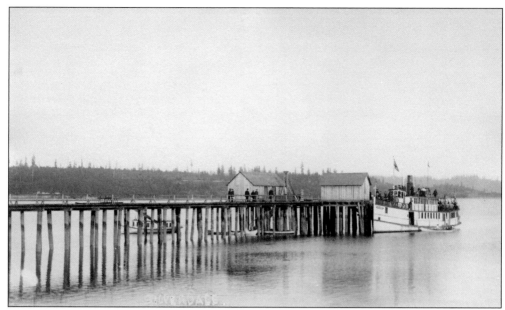

Mosquito Fleet Dock with Steamer Norwood Alongside. Most transportation in Puget Sound was done by water until the advent of passable roads in the 1930s. Hundreds of steam-powered ferries (which, as a group, resembled a swarm of mosquitoes) carried passengers and freight between the various towns and communities. In the 1914 photograph below, Silverdale residents Ed Fellows and Frank Sprague Sr., with his family, stand at the end of the dock waiting for the steamer. Sprague was active in the Methodist church and practiced his sermons at a podium in his living room. Fellows was a custodian for the Silverdale School. The Silverdale Hotel (at far right in the image below) was destroyed by fire in 1924. The Walker (Linn) Hotel is in the center of the image below. In the background, between the two hotels, is a two-story white building—the Silverdale School, which served both elementary and high school students. The long, low building at far left was John Emel's original stable.

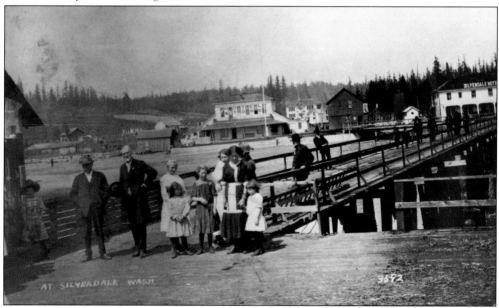

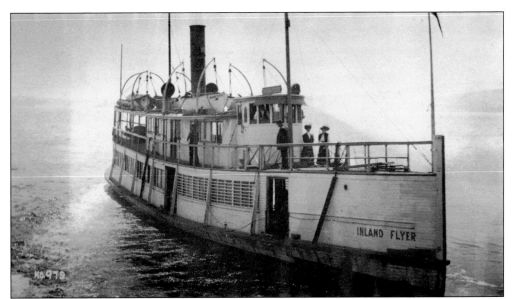

Mosquito Fleet Steamer Inland Flyer. The *Inland Flyer* ran on Puget Sound from 1898 to 1910. She was the first Puget Sound steamer to use oil for fuel. In 1910, the Washington Route, Inc. purchased the *Inland Flyer* and rechristened her as the *Mohawk*. She served the Kitsap area until 1916, when the vessel was dismantled and her engine transferred to a new steamer, the *F.G. Reeve*. The *Mohawk*'s hull became a fish-receiving barge.

Mosquito Fleet Steamer Grace. Based out of Chico, the *Grace* made thrice-weekly runs from Seattle's Smith and Harrington Wharf at the foot of Yesler Avenue, leaving Tuesdays, Thursdays, and Saturdays at 9:00 a.m. and returning on Mondays, Wednesdays, and Fridays at 8:00 a.m. In 1893, the *Grace* was destroyed by fire at the Chico dock.

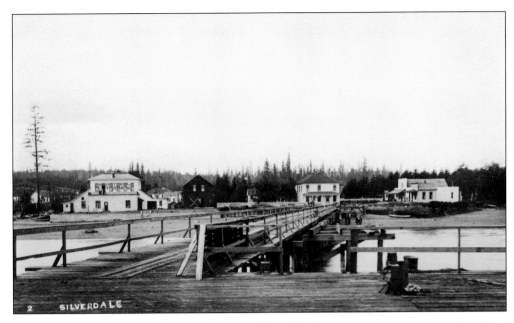

CHALLMAN HOTEL. The two-story building at left in the above image was constructed in 1891 by the Silverdale Cooperative Improvement Association to house a store, a pharmacy, the *Port Washington Sentinel* newspaper, a warehouse, a real estate office, and a community room. However, the cooperative overextended its finances, and the building reverted back to the mortgage holder, William Tell Gaffner, who converted the structure into a hotel and store and moved his business there. In 1901, Gaffner hired managers Emma and Charles Challman (pictured below). Emma bought the business in 1906 and operated it into the 1950s—first as the Challman Hotel, then as the Walker Hotel (after her marriage to Emery Walker), and then as the Linn Hotel (after she married Nels Linn). The hotel was torn down in 1968 to make room for the Silverdale Waterfront Park.

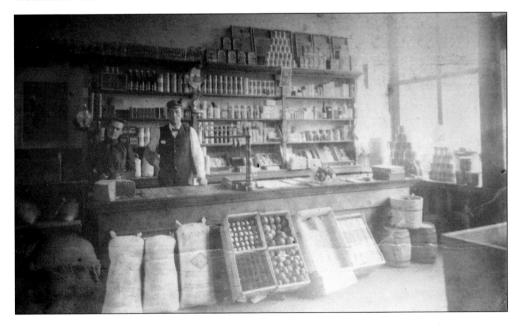

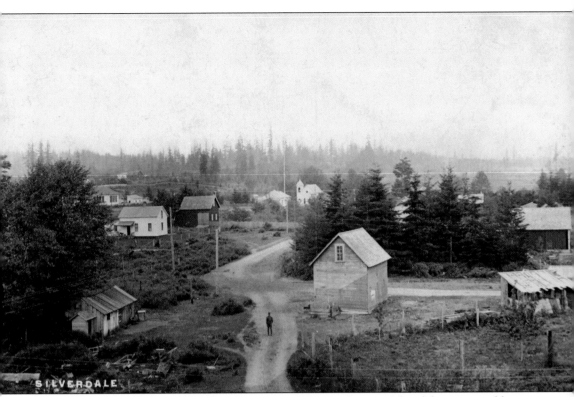

Looking North from the Challman Hotel, 1908. Downtown Silverdale is pictured here. Seen prior to its second-story addition, the Silverdale School is in the far left background. The white building in front of it is Gast's Rooming House. The Methodist Episcopal church, built in 1906, is in the central background.

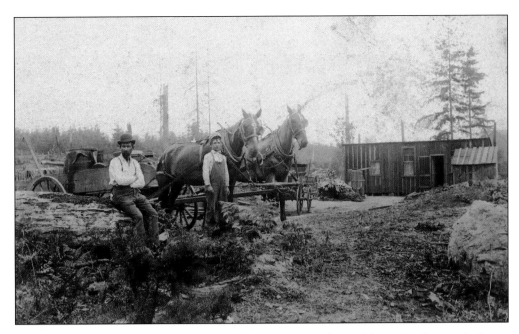

JOHN EMEL. Seeing a need for more ground transportation, John and Anna Emel opened a livery stable in 1908 in a small waterfront shed. In the image above, John (seated) is shown taking a break. The business grew rapidly, and the Emels purchased property on Byron Street, where, in 1911, they were able to start construction of a three-story structure with a livery on the main floor, a second-floor community hall, and a third-floor lodge room. Finished in 1913 (and pictured below), it provided a meeting place for the community and many organizations in addition to housing the livery business. The Emels later ran a restaurant, beer parlor, and barbershop in the building, which now houses Old Town Pub. John also built a horse track in the current location of the Central Kitsap School District bus barn and Central Kitsap Junior High School sports field.

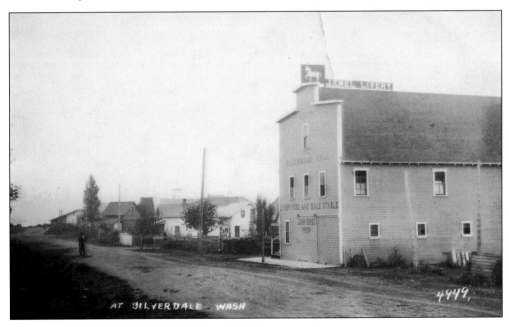

WAAGE FAMILY. Arne M. Waage (pronounced "woggy") arrived in Silverdale in 1908 and purchased the Farmers' Store, a former cooperative building located on the Silverdale waterfront. He changed the name of the store to A.M. Waage General Merchandise and ran the business for many years. The image at right shows Arne and his wife, Anna Berg Waage, with their son, Robert Franklin Waage. Below is a view of the Waage Robbins and Company store, created by Waage's partnership with Bob Robbins after Robbins moved his store from the Silverdale Hotel.

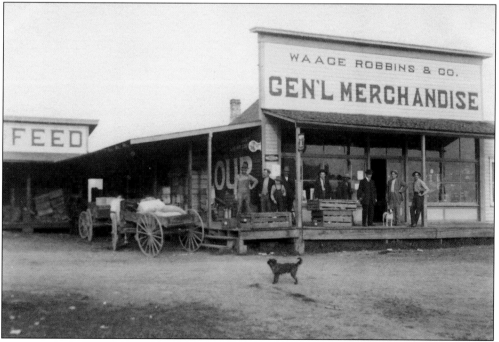

MABEL BERGINE THUESEN ROBBINS. Mabel was born in 1888 to Mads and Lena Thuesen. Mads (Matt) first came to Silverdale in 1884, settling between Fairview and Tracyton. He left and returned in 1889 after marrying Lena Larsen in Wisconsin and went into business in competition with William Tell Gaffner. Robert L. "Bob" Robbins arrived in Silverdale in 1908 and married Mabel. Bob bought Mads's store and post office and eventually became partners with Arne Waage in Waage Robbins and Company, which later became Kitsap Mercantile Company. Mabel succeeded her father as postmistress in 1914 and served until 1922. Bob was chairman of the county Republican Party from 1928 to 1933. Their children were Robert and Bruce Robbins.

Saying Good-Bye in 1907. Nettie Nelson (left), daughter of Central Valley pioneer Nels Nelson, says good-bye to an unidentified friend at the Washington State Normal School at Bellingham, a teachers' school for women. The elegant clothing—from the hat to the shoes—was customary traveling attire for the era. Nettie returned home at age 18 to teach at Central Valley Elementary School. She eventually taught her sister, Margaret, who was 21 years her junior. Nettie married at age 42 and moved to Seattle, living to be 90 years old.

GEORGIA JO BARTLETT. Bartlett's family moved to Silverdale in 1907, and she worked as a telephone operator in Silverdale and at the Bon Marché in Seattle before marrying George Burke in 1912. They eventually moved and raised their family in Pasco, Washington. Standing five feet and nine inches in height, she was considered tall at the time; she is remembered by her family as an easygoing, loving person and an outstanding cook. (Courtesy Barbara Bartlett Flieder.)

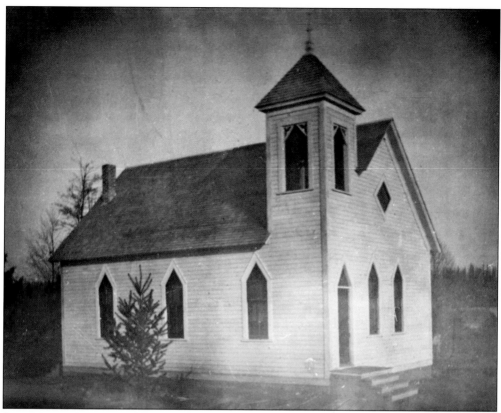

SILVERDALE METHODIST EPISCOPAL CHURCH. The church and parsonage were built in 1906 near Washington Avenue and Carlton Street. A basement added in 1911 served as a community library and contained overflow classrooms for the grade school. The Ladies' Aid Society functioned as a fundraising group for everything from kitchen furnishings to major capital projects. These societies originated during the Civil War and were responsible for educating children; hosting social events; caring for the old, sick, and bereaved; and a plethora of other tasks. The Silverdale chapter of the Ladies' Aid Society is shown below in 1915. Pictured are, in no specific order, Jean Schold, Hanna Holt, Trish Prisk, Edith Schold Wakeman, Ida Linfeldt, Jennie Ingels, Christina Anderson, Edith Palmeter, Minnie Berg, Mabel Robbins, Esther Mattocks, Edith Greaves, Mary Allen, Sophia Peterson, Annie Forsberg, Rose Weir, Lena Thuesen, ? Casper, Mary McDonald, Hazel Bartlett, Maude Hodgson, Florence Bourg, Esther Johnson, Wreatha Moore, Alma Schold, Clara McDonald, Elizabeth Linfeldt, Vida Greaves, and Edith Swackhamer.

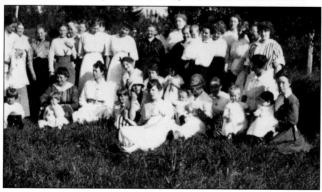

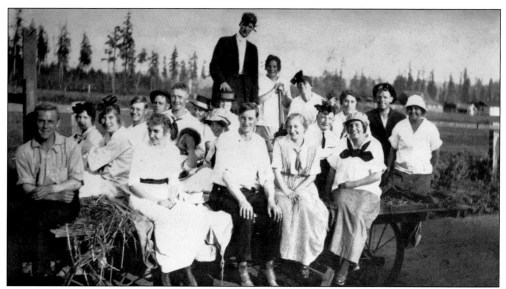

HAY WAGON RIDE, 1908. Hayrides were one of the few opportunities rural young people had to meet and socialize. Pictured, from left to right, are (front row) Violet Johnson, unidentified, Alice Berg, Chester McDonald, Pearl Johnson, Fritz Carlson, and Ruth Johnson; (back row) Charlie Peterson, unidentified, Clara McDonald, unidentified, unidentified, Ervin Berg, unidentified, unidentified, Earl McDonald, Esther Johnson, Clara Peterson, Sybil Gakin, Nels Peterson, and unidentified.

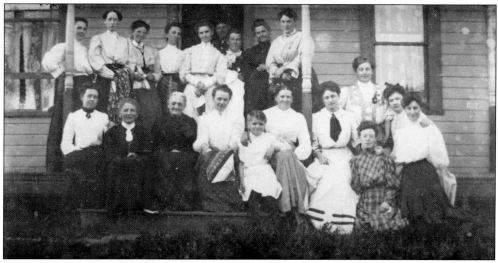

GATHERING AT THE CHARLES HOLT HOME, C. 1907. This was formerly the Littlewood home. Pictured here are, from left to right, (first row) a Mrs. Wendall, Mary Anderson, "Grandma" Fellows, Mary Hatfield, Hanna Holt, "Mother" Hanna Holt, Josie Benbennick, Myrtle McDonald, teacher Edith Fleming, Esther Schold, and teacher Belle Spencer; (second row) Jennie Fleming, unidentified pastor's wife, Margaretta Dingman, Susan Frost, Anna Waage, Edith Greaves, C.V. Hanson, and Mary Lonsdale; Willard Holt is in the doorway.

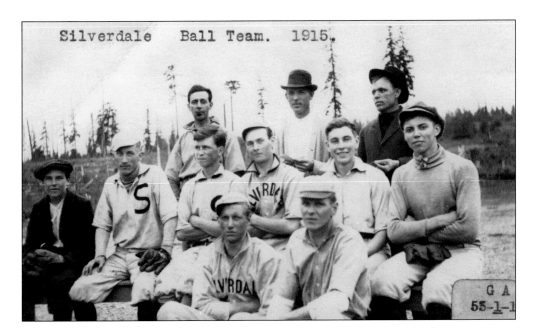

Silverdale Ball Team. 1915.

G A
55-1-1

SILVERDALE BALL TEAMS. From the 1890s and into the 1930s, nearly every town along Puget Sound had its own baseball team. Players traveled to games in other towns via the Mosquito Fleet. The 1915 Silverdale baseball team is pictured above. Shown are, from left to right, (first row) Alfred Peterson and Earl McDonald; (second row) Palmer Peterson, Lynn Sibley, Everett Frost, Ed Wolcott, Ervin Berg, and Albert Holt; (third row) Lawrence Sibley, Eddie Tate (manager), and Nels Peterson. The 1917 baseball team is pictured below. Shown are, from left to right, (first row) Joe McDonald, Palmer Peterson, Bob Swackhamer, Everett Frost, and Erwin Berg; (second row) Lynn Sibley, Ray Wolcott, Norman McDonald, Alfred Peterson, Eddie Tate (manager), and unidentified.

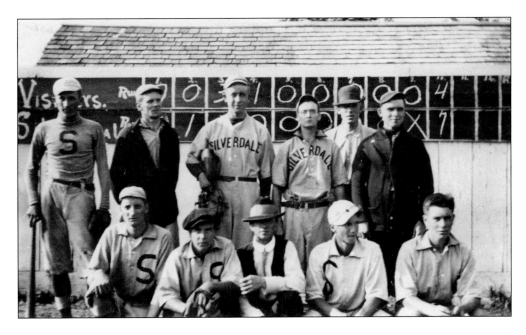

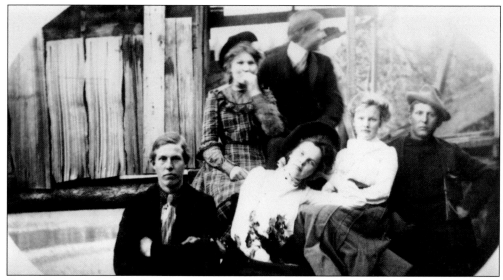

YOUNG PEOPLES' SUNDAY OUTING, 1903. Pictured are, from left to right, (first row) Emil Ekstedt, Gina Hilstad, Chloe Sutton (Island Lake School teacher from 1902 to 1903), and Joe Ekstedt; (second row) Clara Ekstedt and Chris Hilstad. The group had walked from the Ekstedts' to the McIver ranch near Brownsville. Stela McIver is taking the photograph while her sons Ted and Gus are throwing bark chips at the group; Clara is giggling and Chris is telling the boys to stop.

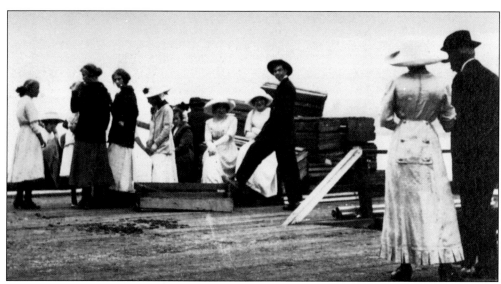

SOCIALIZING ON THE DOCK, 1910. Young and old gather together on the Silverdale dock. At left, wearing dark sweaters, are Clara McDonald and Judith Frost. Martha Braendlein and Genevieve Bourg are seated at the center with Billy Mill (standing, in the dark suit). His parents, Zorada and Jonathon Mill, are at the far right. Jonathon was a chicken rancher as well as a patternmaker in the Bremerton shipyard.

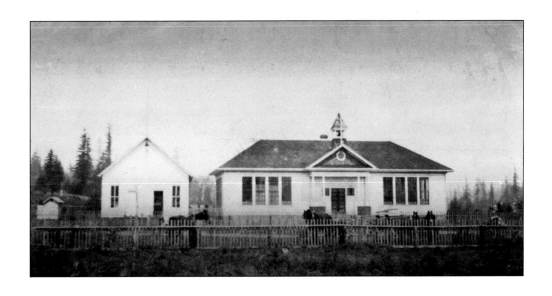

SILVERDALE SCHOOL. The Silverdale School was completed in 1905 near the intersection of Carlton Street and Pacific Avenue. The one-story, two-room school replaced the smaller building (on the left in the image above). Due to the growing number of students, a second story was added in 1911; this was accomplished by raising the building and adding a first floor underneath it, as shown in the photograph below. By 1915, high school students were no longer taught here—they finished their educations in Bremerton or Seattle until 1923, when Silverdale's Port Washington Bay Union High School No. 6 was built at Bucklin Hill and Anderson Hill Roads.

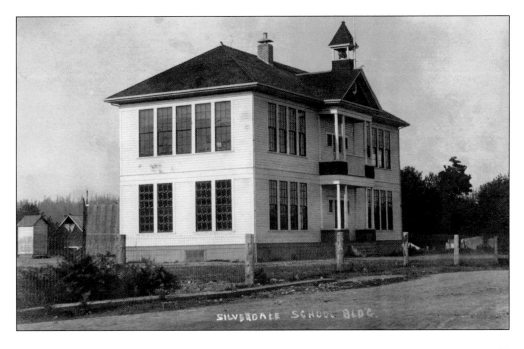

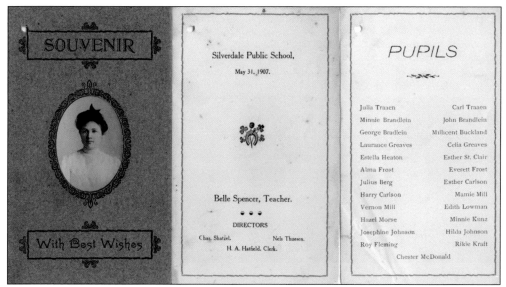

Silverdale Public School Souvenir, 1907. Lillian "Belle" Spencer was the teacher when the school was still single-story, and the 25 pupils listed represent the broad geographical range in the Central Kitsap area. Spencer and her widowed mother and brother, Earl, moved from Seattle when she and Earl found employment in Kitsap County. By 1912, she was again living in Seattle.

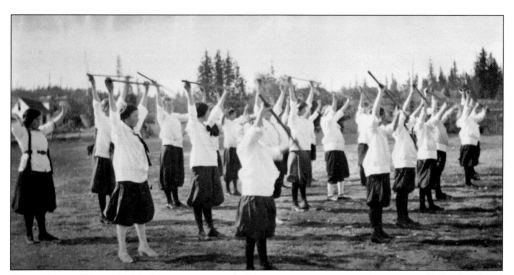

Wand Drill Team, 1915. Participation in drill teams was a very popular activity for high school girls in this time period. Note the homemade bloomers commonly worn by young women for athletic activities.

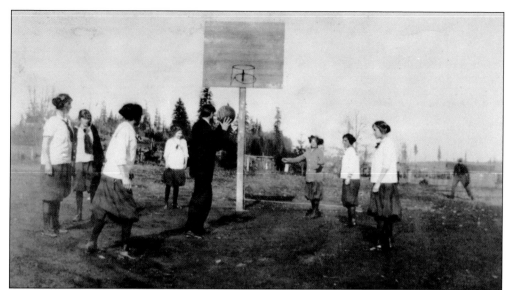

GIRLS' BASKETBALL. The game of basketball made its debut at Smith College in 1892, one year after James Naismith invented men's basketball. The game quickly caught on throughout the United States, and Silverdale was no exception. The Silverdale High School girls' basketball team of 1913 is pictured at right; shown are, from the top to the bottom, Clara McDonald, Violet Anderson, Clara Peterson, Helen Nelson, Judith Frost, Pearl Johnson, and Grace Bourg. At a practice session pictured above, the players look on as their coach, teacher, and principal Prof. Bernard Duskin shows them some moves. Shown above are, from left to right, McDonald, Frost, Peterson, Johnson, Professor Duskin, Anderson, Bourg, and Nelson. By 1925, some 37 states held high school varsity basketball and/or state tournaments.

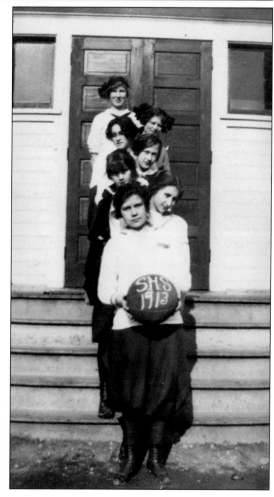

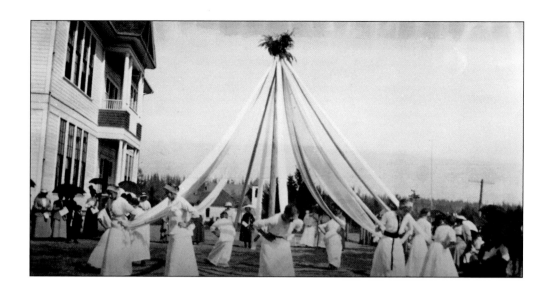

MILK MAIDS AND PEASANT DANCES. As part of the last day of school celebration picnic in 1915, high school girls perform a springtime "milk maids" dance around a maypole in front of the Silverdale School. The matching dresses and hats were made especially for the occasion. In the 1914 image below, girls perform a peasant dance. Costumed dances demonstrate the diversity of the area, as many settlers were of Scandinavian origin, with English, Irish, Scottish, and other European families joining in for activities. (Below, courtesy Barbara Bartlett Flieder.)

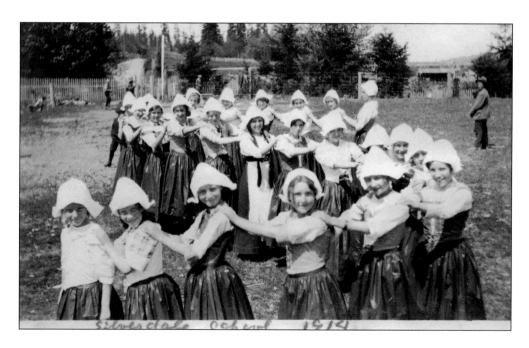

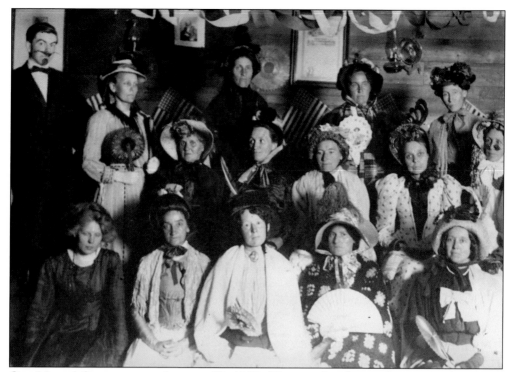

OLD MAIDS' CONVENTION, AUGUST 22, 1913. "Spinsters' gatherings" were popular events throughout the country in the early 1900s. This frivolously-named evening featured popular music and dramatics to raise funds for community projects. Pictured are, from left to right, (first row) Grace Anderson ("preacher's daughter"), Rose Weir, Catherine Tate, Lillian Kegley, and Mary Windel; (second row) unidentified, Susan Frost, Bretta Johnson, a Mrs. Lendrum, and Margeret Brandenberg; (third row) Vernon Mill, Lulu May Bourg, Cora Gakin, Myrtle Thuesen, and Edith Swackhamer.

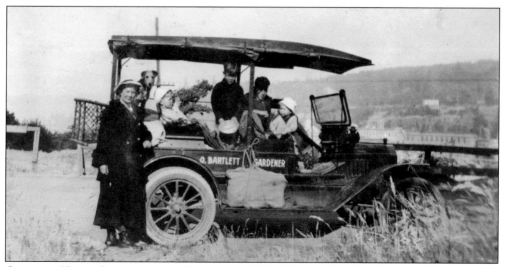

OTIS AND HAZEL BARTLETT AND THEIR CAR, 1917. The Bartlett family enjoyed short trips in the car that was normally used twice a week to transport the bounty of their farm to market in Bremerton. (Courtesy Barbara Bartlett Flieder.)

CLARENCE BENBENNICK'S JITNEY FOR HIRE. Benbennick had the first automobile in Silverdale and operated the first jitney service in the area. Before purchasing the car, he drove a horse team for Emel's Livery Stables, the area's first land-based transportation service. After meeting the boat with horses Queen and Sassy, he would take incoming passengers wherever they wanted to go in his two-seated buggy, sometimes traveling as far as Seabeck.

SILVERDALE GARAGE, GUY MCCOLLUM, PROPRIETOR. In 1910, McCollum, a blacksmith by trade, opened a small shop on the northwest corner of Byron and Washington Streets. In 1914, he bought the northeast corner lot at the same intersection and opened an automobile garage in conjunction with the blacksmith shop. During World War II, this was rebuilt as the Motor Pool for the 202nd Artillery Detachment, and the building is still in use today as an auto-repair shop.

PETER F. EMEL, 1918. Emel is shown with his 1917 Ford camper truck, in which he journeyed to California and back over the primitive roads available at the time. (Courtesy Darrel Emel.)

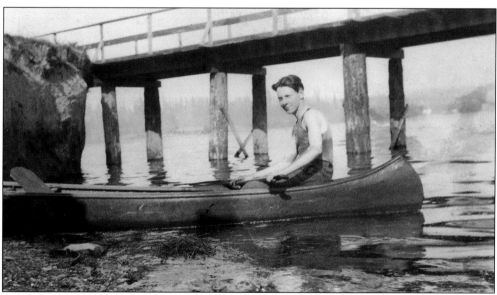

JESSE "RED" JONES. Shown beaching his canoe near the Silverdale Dock in 1919, Jones was born aboard the USS *Nipsic*, the headquarters for the Navy Yard Puget Sound, where his father, Jesse E. Jones, was a warrant officer. After a 30-year career as a shipyard machinist, Red retired and, with his wife, Edith, owned and operated the Jones Nursery and Florist Shop in Silverdale.

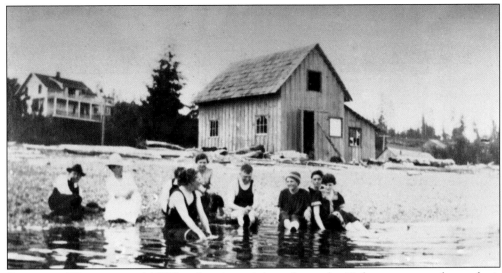

SWIMMING. Wearing typical 1915 beach attire, swimmers brave the 60-degree water at the sand spit in front of the Anton and Minnie Bourg home on Dyes Inlet. Beriah Brown's barn (foreground) was used as a changing room and bathhouse. The Bourg property was located near the foot of today's Newberry Hill Road. The white house on the hill behind the swimmers is the home of Capt. Martin Madison.

HARRY EDGAR PALMETER, 1918. Palmeter is shown astride his Excelsior motorcycle near Dyes Inlet when the road ran along the beach on a causeway. In the background is one of the cottages used by the Frank Bourg family when they moved onto their property in 1912. Edgar A. Palmeter, Harry's father, moved the family to Clear Creek Road in 1914. Edgar was the manager of the Silverdale Poultry Association in 1916 and 1917.

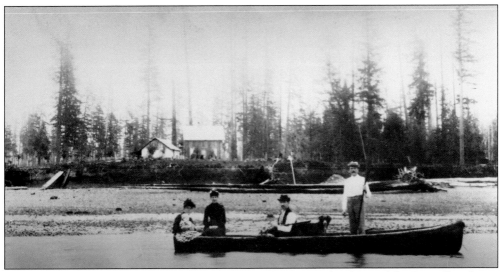

CHRIS AND LIZZIE BRAENDLEIN FAMILY FISHING, 1891. Pictured in front of the Braendlein home are, from left to right, Chris's sister, Fredricka Kraft, Lizzie and Chris Braendlein, and Karl Kraft (standing). Chris's rowboat was his primary transportation for frequent trips to Charleston and Bremerton (delivering produce), Port Madison (mail), and Port Orchard (Masonic lodge). In 1898, he was a meat supplier for the Navy ships and barracks. He served as a road supervisor, Kitsap County commissioner, and acting coroner.

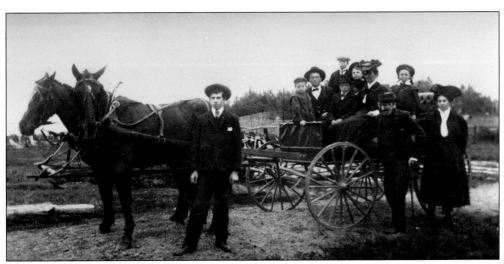

HEADING TO CHURCH, 1910. Chris's daughter Minnie recalled the "Sunday Safaris": "After our noon meal, Dad loaded us in the wagon, later into the two-seated upholstered buggy," she said. "He taught us so many things: names of trees and bushes and the names and position of stars, the moon phases."

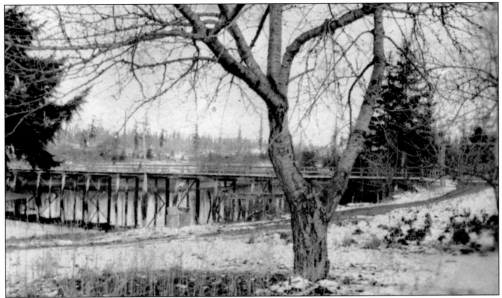

THE SILVERDALE-TRACYTON BRIDGE. Chris Braendlein completed this bridge over Clear Creek in 1907. It was a 200-foot-long span of split cedar planks. Later, the tidelands were filled with dirt and paved to make a road, and the creek was fed through concrete culverts. Since that time, it was determined that these culverts inhibited creek discharge and salmon migration.

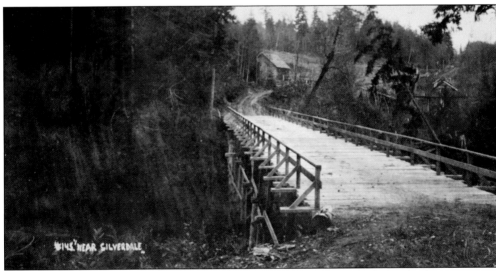

CASSEL CREEK BRIDGE, 1910. Built along the Silverdale-Tracyton Road, this bridge was strong enough to support a fully-loaded wagon and a team of horses or mules. However, the road at either end was little more than a rutted trail that would become nearly impassable after a heavy rain. In addition to other large properties, Henry Cassel owned the property that straddles the waterway that was called Barker Creek by 1926.

SWEDISH FREE MISSION CHURCH. This, the first church in the Silverdale area, was built on land donated by Albert Johnson in 1903. Early settlers paid for and built what became the community's social center. Ladies' Aid Society fundraising took care of maintenance and provided many kitchen furnishings. When the building became home to Silverdale Grange, the congregation moved to the Bible Church in Old Town Silverdale, taking the bell along.

FIRST CLEAR CREEK SCHOOL. After this school was built on property donated by Andrew Schold and John Holm, the first classes were held in 1897. Teachers Miss Gray and Mary Page are pictured here with students in 1906. In 1908, after a second schoolhouse was built elsewhere, Schold bought back this property for $150 gold coin and converted the building into a home for his son, Albin. It burned down in the 1960s, and the site is now part of the Petersen Farm.

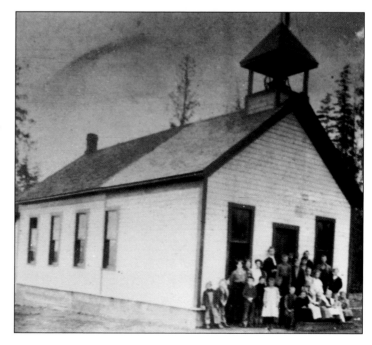

ALBIN AND JEAN HINDS SCHOLD. In the image at left, Albin Schold, son of Andrew and Hanna Schold, stands with his fiancée, Jean Hinds, in 1913. Albin was the proprietor of the Silverdale Hotel, as shown in the 1913–1914 Polk Directory advertisement below. He eventually returned to dairy farming. After Albin and Jean married in 1915, Jean stopped teaching school, and they lived in the original Clear Creek schoolhouse that adjoined the Schold farm.

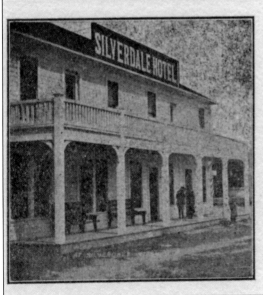

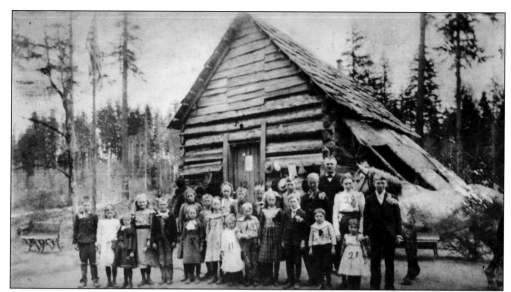

BROWNSVILLE SCHOOL. This one-room school was erected in 1894 on the corner of William E. Sutton Road and the Brownsville Highway. In 1904, when it became clear that the school was too small, the Jim Scott home, located near what is now the Brownsville Marina office, was used until a new school was completed on John Paulson Road near Ogle Corner.

SOUVENIR

School District No. 30.

Brownsville,
Kitsap Co., Wash.

1896

PRESENTED BY

Wm. E. Sulton,

Teacher.

Directors.

Ed F. Lougee,
Lewis Peterson,
Andre Nielsen.

BROWNSVILLE SCHOOL SOUVENIR, 1896. Brownsville is located one mile east of Silverdale on the east side of the Kitsap Peninsula. William E. Sutton Road, which runs east off Waaga Way, was named for this teacher.

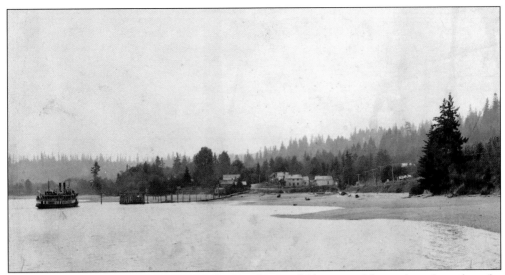

CHICO DOCK AND BUILDINGS. In 1892, the population of Chico was 25, equaling that of nearby Silverdale. By then, the Sutherland Hotel had been built by Capt. George C. Sutherland and was the largest building in the community. This early-1900s photograph shows two hotels, the general store, a pharmacy, several homes, and the floating Mosquito Fleet dock.

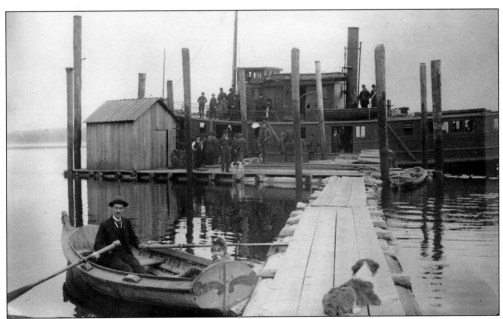

MOSQUITO FLEET STEAMER MOUNTAINEER AT CHICO. In this image, the *Mountaineer* unloads passengers at the Chico floating dock one mile south of Silverdale. Chico's dock was built in 1905, and the town was one of very few ports using a floating dock. The 64-foot *Mountaineer* was built in Chinook, Washington, in 1883 and stayed in service until 1940. Note the craftsmanship of the carvel-planked rowboat in the foreground.

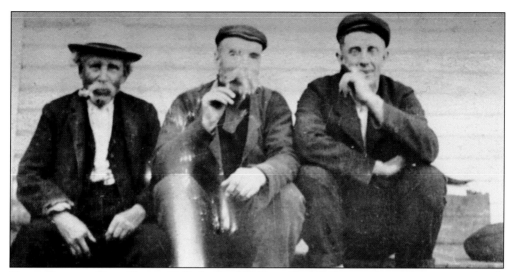

CHICO FRIENDS. Capt. George C. Sutherland (left) and Jack F. Dawson (center) are pictured with friend Ed Parsons from Port Blakely. Captain Sutherland arrived in Chico in 1889 and by 1892 had built the Sutherland Hotel. Dawson built Chico's first store, Dawson's General Merchandise, in 1889.

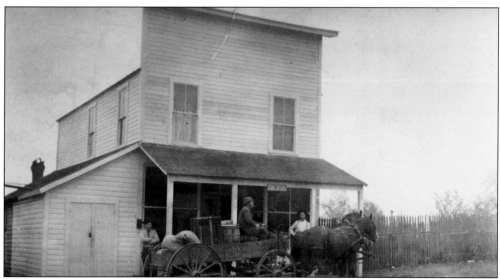

EDWARD DRAKE STORE, CHICO. Drake was looking for work in Seattle when he saw an advertisement for the sale of a general store in Chico. Thinking it was as good a time as any to learn the business of general merchandising, he took the boat to Chico and bought the store from Ben Sparks. Because the post office was in the building, he automatically became postmaster.

LITTLEWOOD GRAVE MARKER. To honor the area's first recorded settler, William Littlewood, the community erected a very distinctive marker for his grave located in the Silverdale Pioneer Cemetery on Anderson Hill Road, just past the soccer fields. Over the years, vandals have broken off the axe handle, bird's head, and other parts. (Courtesy Claudia Hunt.)

SILVERDALE COMMUNITY MEMORIAL. This memorial was dedicated in 1922 to honor Pvt. Henry Richard Johnson, Company C, 101st Infantry, who was killed in action during the Meuse-Argonne offensive in France a few days before the end of World War I in 1919. Originally placed on the grounds of the Silverdale Grade School, which is visible in the background, it was moved multiple times and is now located in Silverdale Waterfront Park beside the gazebo.

Two

MIDDLE TOWN
1921–1945

For the pioneer families with homesteads near Silverdale, the early decades of the 20th century ushered in a period of change. The First World War created a booming economy for Kitsap County. Some immigrant families saw the war effort as a way to repay the United States for the free land they had been given; young men enlisted in the armed services, while older men took war-related jobs.

At the end of the war, the increased population—due to wartime employment at the shipyard—fed the demand for agricultural products. Dairy farming gained importance in the lush valleys of Central Kitsap. A growing market for canned vegetables, fruit, and berries also proved profitable for area farmers. Area youth participated in summertime berry-picking. For farm children, it was part of the routine; for town-dwellers, it was a source of extra income. Produce was shipped to a major cannery just south of the city of Tacoma.

Closer to home, the farmers' cooperative movement lowered feed prices for area chicken ranchers and helped to stimulate the industry. A warehouse located at the end of the Silverdale dock served as a site for egg candling and packing the eggs for shipment to a central distribution point in Seattle. Live chickens no longer producing eggs were shipped to Seattle processing plants.

New infrastructure transformed Silverdale. Roads connecting the outlying areas to the population center made it possible for both goods and people to easily flow into and out of town. Roads also enabled farm families to gather at local meeting halls for dances, potlucks, religious services, and general socializing. Cars and trucks quickly replaced the horse and wagon.

Transportation to Seattle continued to be by water, but there was an added emphasis on boating excursions for the purpose of recreation and sightseeing.

Electricity and a community water system were another part of the town's development in the 1920s. Along with those advances came a new high school and gymnasium. High school sports for both boys and girls drew the community together just as effectively as the roads had.

LOMBARDY POPLARS. These Silverdale landmarks flourished on the Greaves homestead, located near the present-day Kitsap Mall, for years until old age, storms, and urbanization destroyed most of them—although a few can still be seen. In 1907, Silverdale pioneer Nels Thuesen visited Denmark, took cuttings from trees related to Napoleon's poplars on the island of St. Helena, and brought the cuttings back for a friend in Silverdale.

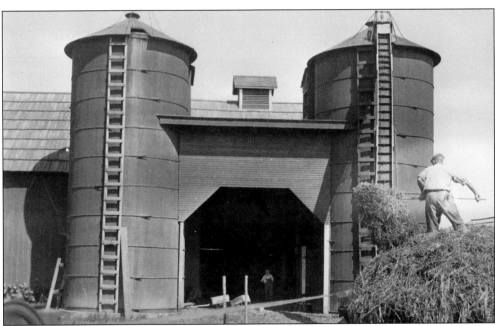

BILL GREAVES PITCHING HAY. While working the farm purchased by his parents in 1894, Greaves went to Washington State College at Pullman to learn about new farming methods. The silos, made of wooden staves and steel bands, were used to store winter fodder as an alternative to hay and grain. Silage is highly nutritious, and cows respond with increased milk production. The Greaves family sold the property to the developer of the Kitsap Mall in 1984.

SILVERDALE STATE BANK.
The bank was founded
in 1919 at the corner of
Washington Avenue and
Byron Street. Robert
Gordon (right), shown
with Edwin Nelson,
started working at the
bank as a cashier in 1922,
becoming president in
1940. The bank moved
in 1976, and the building
became the Kitsap
County Historical Society
Museum; in 1995, the
museum moved to a bigger
building in Bremerton
and this structure became
a doctor's office.

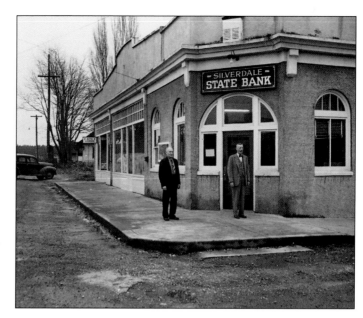

ED NELSON. In 1925, Nelson bought the Silverdale Drug Store, located in the Silverdale State Bank building. He renamed it Nelson's Drug Store, then Silverdale Sundry Store. He moved it to Highway 21 in 1955, operating there until he retired in 1957. The soda fountain was a gathering place even after the drugstore moved to the new location. Students at Port Washington Bay Union High School remember going there on Fridays to pick up sandwiches for their teachers.

PORT WASHINGTON BAY UNION HIGH SCHOOL DISTRICT NO. 6. Located at Bucklin Hill and Anderson Hill Roads, the eight-room school building, intended for students in grades nine through twelve, was constructed in 1921 thanks to donated labor and pledges from 96 families; the school was completed in 1923. The above photograph shows a work party participating in the clearing of land for the new high school; the group includes Everett and Richard Frost, Nels and Myrtle Thuesen, William and Bill Greaves, Herbert Nelson, Paul Peterson, Robert Swackhamer, Minerva Kitts, three unidentified people, Ted Paulson, Samuel Nave (the school's first principal), Charles Ekstedt, Herman Myhre, Dan Radovich, Andrew Anderson, and Emma Linn. The school's name was changed to Central Kitsap High School in the early 1940s, when the state combined multiple districts into a larger "high school" district. The building was eventually replaced at the same location by the current Central Kitsap High School; however, the front steps, visible in the image below, remain.

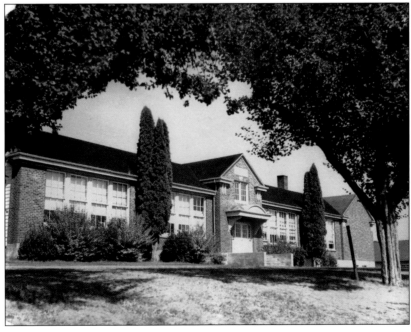

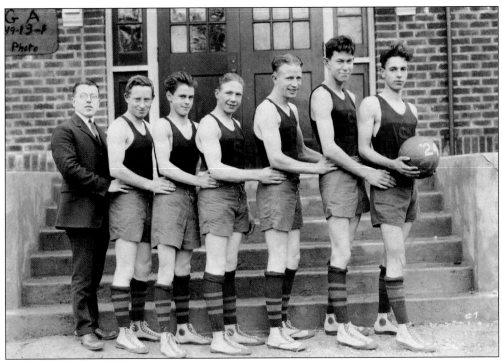

PORT WASHINGTON BAY UNION HIGH SCHOOL BASKETBALL TEAM, 1924. In the first decades of the 20th century, the indoor game basketball became the ideal interscholastic sport throughout the nation, allowing students to stay active throughout long, inclement winters—and Silverdale was enthusiastically on board. The team is seen here with Coach S.A. Nave. In addition to playing other schools, it played the Navy Yard Apprentices, the Naval Ammunition Depot team, and Silverdale Town team.

CAPT. MARTIN MADISON. Captain Madison bought two acres of waterfront land a quarter-mile south of Silverdale. He and Fred G. Reeve owned the Washington Route, Inc., Mosquito Fleet ferries serving Kitsap, Snohomish, and King Counties. After retiring from the ferries, Madison operated a combination gas station and grocery store at the foot of Newberry Hill Road. The sign on the north end of the building is still visible.

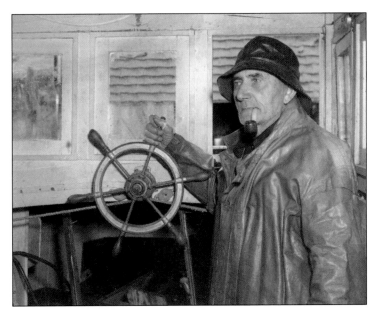

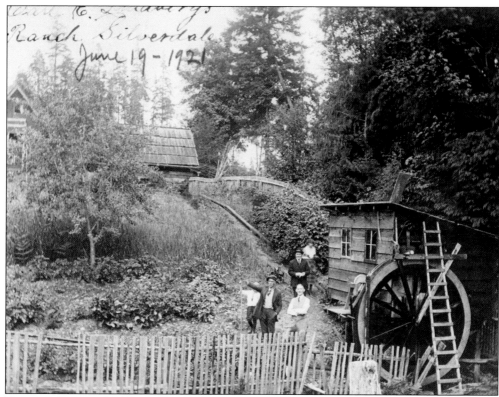

LINDBERG RANCH. Carl E. "Cully" Lindberg emigrated from Sweden to the United States in 1896. He arrived in Silverdale in 1905 with his wife, Anna, and their three children. They settled on Anderson Hill Road, where Lindberg planted fruit trees and berry bushes. In 1921, he built a dam and the waterwheel, as shown in the lower-right corner of the above image. This provided electricity for his home, water for his crops, and power for his machine shop inside the wheelhouse. The creek is now called Strawberry Creek, with a tributary called Koch Creek. Cully's grandson Paul Harshbarger still lives in the home. The people on the bridge above the dam in the image below are members of the Svea ("the Swedish nation") Male Chorus who are on holiday. Cully was a member of this group, which originally formed in Seattle to furnish entertainment for local Swedes and to preserve music from the homeland. (Both, courtesy the Lindberg family.)

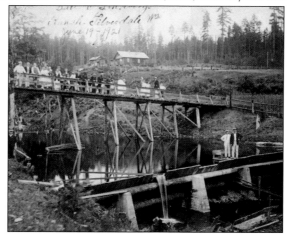

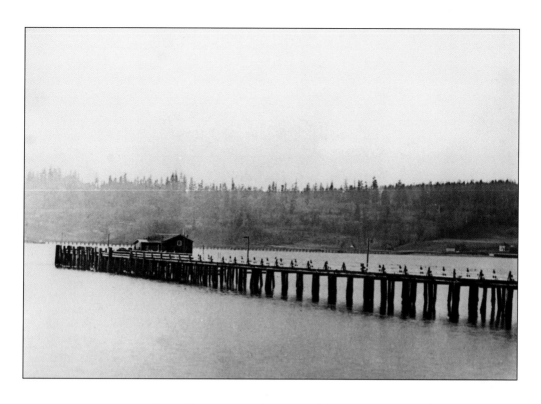

SILVERDALE'S MOSQUITO FLEET PIER. The background of the above photograph shows the long causeway connecting Chico to Silverdale. In 1908, John Paulson, of Central Valley, and Peter Glud, of Brownsville, were hired build the road connecting the nearby town of Chico with Silverdale, which also required bridges over a half-dozen creeks. When the highway was relocated up the hill and off the beach, it became Highway 21, but is now known as Silverdale Way. The image below shows the ramp that allowed some of the ferries to handle cars as well as passengers and freight; this continued until the mid-1930s, when roads were improved and many Mosquito Fleet runs were discontinued.

ELECTRICITY ON BYRON STREET. With a wheezing old gas engine and one incandescent bulb lighting up the parlor of the Linn Hotel, Louis C. Morey (left) started the Silverdale Light and Power Company with a borrowed $50 in 1922. By 1929, when he sold to Puget Sound Power and Light, he had hand dug power-pole holes for 70 miles of main line with 420 customers in and around Silverdale. Morey stayed on, operating the Silverdale Electric Company store, where he sold electrical equipment and hardware. In the image below, Byron Street is lined with power poles. Silverdale Electric is the third building on the left, with an advertisement for coal on the side of the building. Emel's Livery and Restaurant is the large building on the right, with a Union Service station just beyond it advertising "Stage Depot." Silverdale State Bank is in the distance.

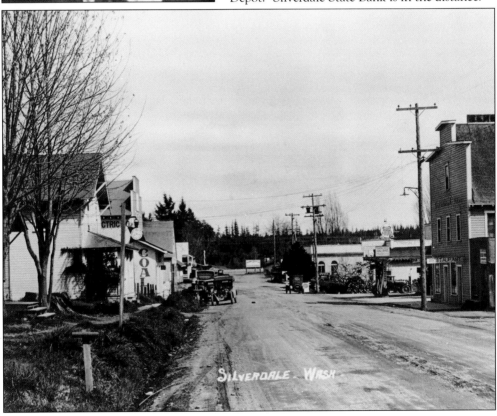

LOWELL STREET AT HIGH TIDE. Thomas Hynes, shown on his porch dressed in his signature overalls, came to Silverdale in 1927 at the age of 62. Locals believed he was a bachelor but later discovered that he had children. He started the *Silverdale Breeze* newspaper in January 1928. In February 1933, Hynes wrote in the *Breeze*: "Bombastic Storm. The *Breeze* office is located several hundred feet from the shore. Only twice in our five years' occupancy of this building has the tide reached us. On this occasion the water flowed up the street almost to the bank. And when logs and wood drifted up to the door and water began to bubble up thru the floor, we thought it time to move."

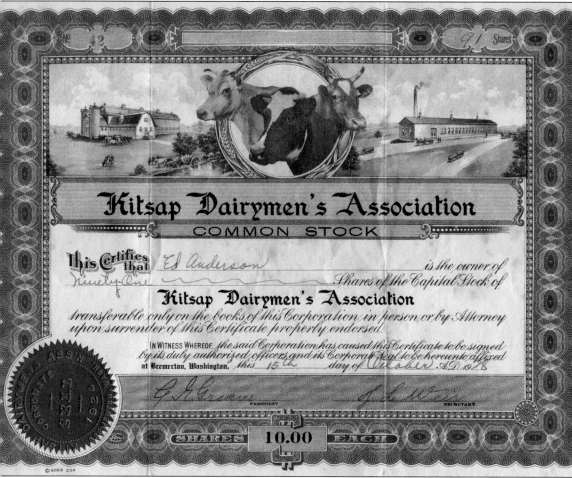

KITSAP DAIRYMEN'S ASSOCIATION STOCK CERTIFICATE NO. 42, OCTOBER 15, 1928. Ed Anderson purchased 91 shares at $10 per share in the association that began on June 7, 1924, when the dairy farmers of Silverdale and Central Valley bought the Jacobsen dairy in Bremerton. After serving the entire county, the association went out of business in 1969.

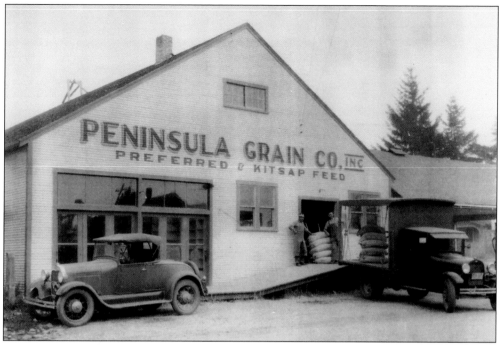

PENINSULA GRAIN COMPANY. Charles G. Vaughn founded the business in Port Orchard in 1923. He opened this Silverdale store with his son, Clyde M. Vaughn, in 1929. They were in direct competition with the local cooperative and shipped eggs and poultry daily. In the image above, manager Ernst William Blankinship, Charles's son-in-law, is on the left. The truck at the loading dock is a 1929 Ford. The company's name was changed to Peninsula Feed Company in 1934. Other employees included Howard Amende and Bob Sorenson, managers; Bob Robbins, truck driver; and Wallace Stottlemeyer, egg candler (testing eggs with light to determine embryo development) and also a miller to mill grain into poultry feed. The wooden shipping crates, which could hold 30 dozen eggs, were made by the Seattle Box Company and required a jig to place the pieces to make it possible to nail the parts together. Crates were interchangeable with any company, irrespective of its labeling. (Above, courtesy Don Vaughn; below, courtesy Wallace Stottlemeyer.)

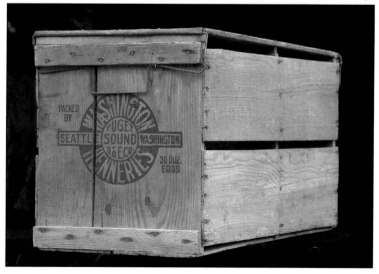

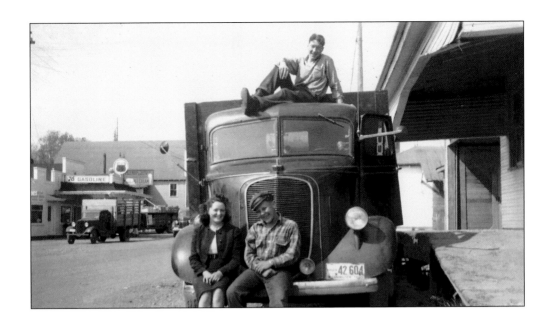

BYRON STREET, 1940. Seen from the loading dock of Peninsula Grain Company, this block of Old Town Silverdale offered it all. The 76 Gasoline station served meals and ice cream and had a billiard table and a barbershop. Next door was Greaves' Grocery Market, and Emel's livery stable building was just beyond, with a tavern, restaurant, and meeting hall on the upper level. In the above image, the Peninsula Grain Company's hay-hauling crew takes a break in front of the store; Carl Tornensis is on top of the cab. In the image below, Ruth Dement, a local girl, is in the foreground. (Both, courtesy Wallace Stottlemeyer.)

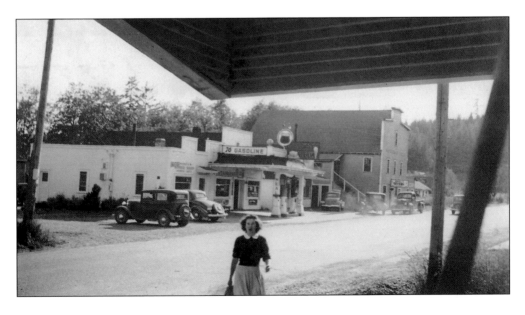

SILVERDALE METHODIST EPISCOPAL CHURCH AND PARSONAGE. The church was built in 1906. Remodeling in the 1930s added wings, a central entry, and a smaller bell tower. The buildings at 3382 and 3392 Carlton Street have housed a variety of tenants since, and though the bell tower was removed, the original integrity of the church remains. In 1962, a new Silverdale Methodist Church was built at Silverdale Way and Kitsap Mall Boulevard.

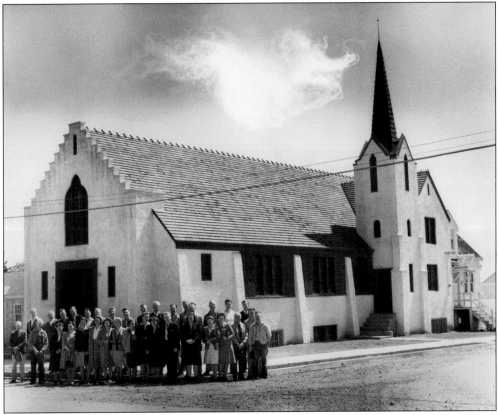

SILVERDALE BIBLE CHURCH. This church was erected by its pastor and congregation and cost less than $11,000. Here, the congregation poses for a picture on the day of its dedication in May 1947. Pastor I.S. Nazarenus's extensive background as a building contractor made it possible for him to design the building and supervise the unskilled members of the congregation through the various stages of construction.

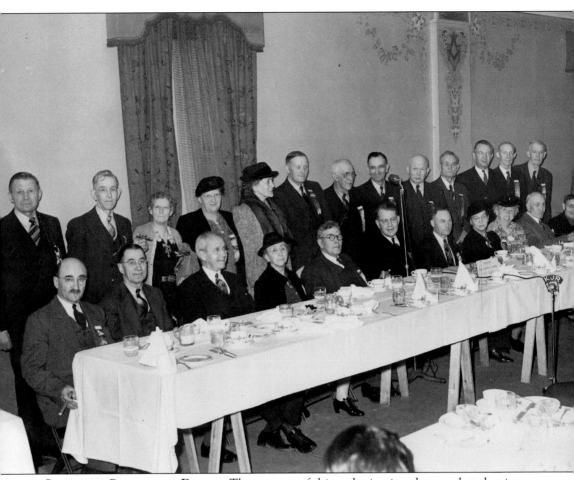

SILVERDALE COOPERATIVE DINNER. The purpose of this gathering is unknown, but the sign on the table reads: "Reserved for Charter Members and Guests." Otis Bartlett is seated fifth from the left. Note the microphone in front of the table with the call letters KJR—a popular Seattle radio station founded on March 9, 1922. The station was owned by entertainer Danny Kaye and Lester Smith (Kaye/Smith Enterprises). (Courtesy Barbara Bartlett Flieder.)

CALENDAR FROM SILVERDALE POULTRY ASSOCIATION, 1934. Businesses have long been giving free gifts as a way to gain loyal customers. John Morrell & Co. produced this promotional calendar, which includes holidays, presidential birthdays, and other historically significant dates. Note that at the time, area telephone numbers contained only two digits.

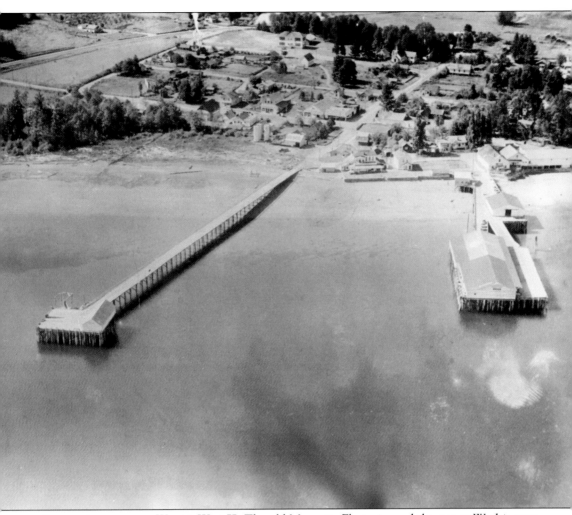

Silverdale prior to World War II. The old Mosquito Fleet pier and the newer Washington Cooperative Egg and Poultry Association dock are both visible in this late-1930s image. Ships would deliver feed and other farm supplies, then load eggs and poultry for shipment to Seattle and other markets. It was considered an "experience" to drive on the loose boards of the dock. Many other buildings are visible in this aerial photograph. Transportation was still limited at this time, and most social activities were oriented toward local communities. It was a significant event to visit the dock, hotel, and other businesses in town. (Courtesy Cordell and Bonnie Sunkel.)

CHICO-SILVERDALE ROAD. This road was moved up from the beach in the late 1930s and labeled Highway 21 (now Chico Way). It replaced the road and causeway along the beach, which was built in 1908 by John Paulson and Peter Glud and bridged a half-dozen creeks. The road connected Silverdale to Crosby via a Chico-Crosby road built in the 1880s.

BUCKLIN HILL ROAD LOOKING WEST TOWARD SILVERDALE. Roads were built and maintained by local citizens who chose to donate labor in lieu of paying a road tax. Bucklin Hill was named for Edwin and Ida Buckland (misspellings by mapmakers have always confused historians) and their six children, who lived on an 80-acre farm at the top of the hill in a long log house.

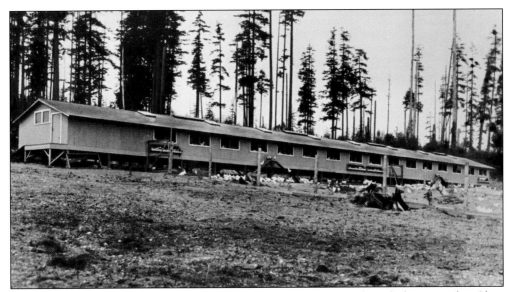

CONRAD PETERSON'S CHICKEN HOUSE. Peder Peterson, a logger, purchased a homestead in Clear Creek Valley in 1885. His nephew, Conrad Peterson, developed it into a poultry farm in the early 1900s. George and Margret Juricich purchased the farm in 1949 and finally retired from the egg business in 1980. Since then, the farm has been diversified and operated by their daughter Nikki and her husband, Allen Johanson, under the name Pheasant Fields Farm. In the photograph below, Conrad and Olga Peterson are feeding their white leghorn chickens.

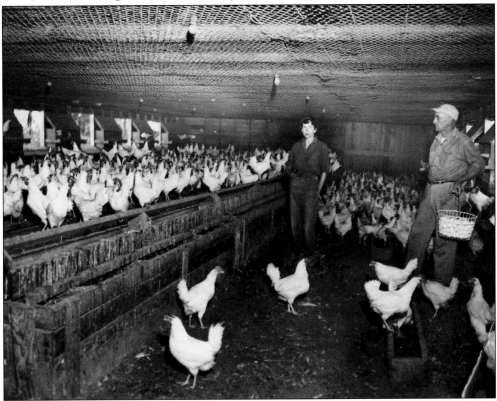

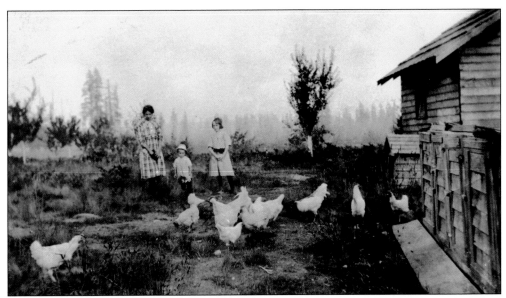

ADNA (LEFT), FRIEDA (CENTER), AND JOSEPHINE DAHL WATCHING THE CHICKENS, 1920S. Their parents, Hans and Pauline Dahl, arrived in Central Valley a decade earlier and began chicken ranching. By the 1920s, everyone was helping Silverdale Cooperative set egg-shipping records. Eggs from Silverdale were packed in wooden crates, went by ferry to Seattle, and then traveled as far as Chicago by train. Here, the girls prepare to feed the chickens. (Courtesy Marlene Brooks Hattrick.)

CLAIS AND AUGUSTA GUSTAFSON FEEDING THEIR CHICKENS. Clais and his second wife, Augusta, are pictured here in the early 1940s. Augusta loved beautiful clothes and was deeply religious. After discovering moth damage in her treasured wardrobe, she felt the Lord was punishing her for her vanity. Clais and Augusta farmed until 1943, when they sold out and entered the Ebenezer Home, now known as Martha & Mary Retirement Apartments, in Poulsbo. (Courtesy Norma Peterson Card.)

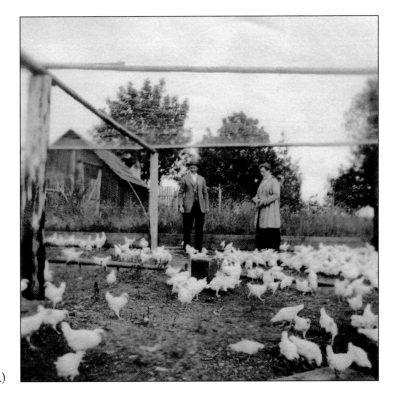

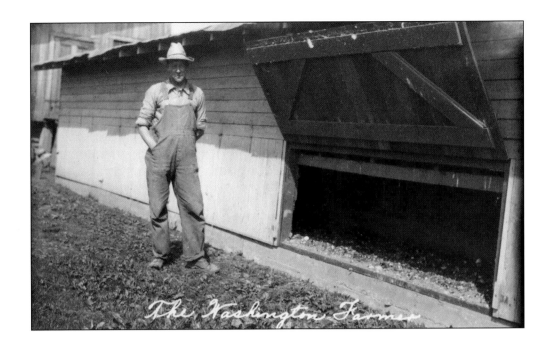

CHICKEN RANCHERS GET CREATIVE. Jack Ware (pictured above) devised a labor-saving system that allows cleaning from under roosts without going inside the henhouse. Below, poultryman Oliver Hagener sells fryers from his truck. Since he did not have access to refrigerated trucks, Hagener traveled the county selling live chickens, thus ensuring their freshness.

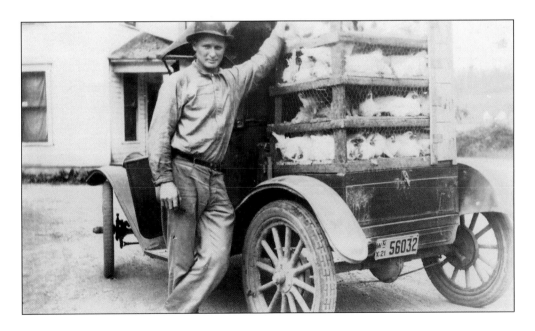

VIRGIN GROWTH TREE STUMP, CENTRAL VALLEY. In the image at right, members of the Paulson family pose near a stump on their homestead. Pictured, from left to right, are Julius Gjersvold, Myrtle Paulson Gjersvold, Ione, Laura Paulson Walden, Anna Paulson, and Ella, along with an unidentified man in front. In the photograph below, George N. Worden, Kitsap County agricultural agent from 1920 to 1936, is demonstrating techniques to dynamite stumps as an alternative to digging and burning stumps to clear land for farming. The only other option for farmers was to farm around the huge stumps. Extension programs from Washington State University are still responsible for presenting useful information related to agriculture, business, economics, and much more. (Right, courtesy Alan Paulson.)

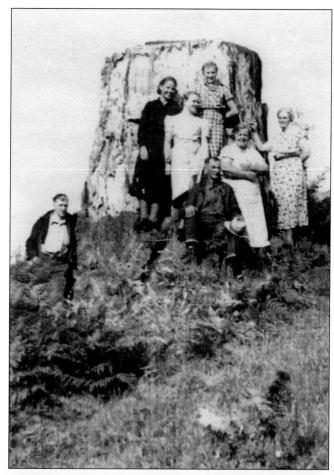

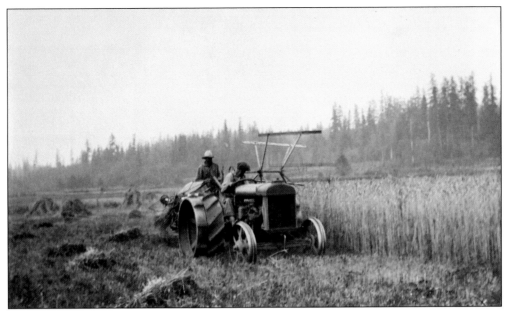

WHEAT HARVEST ON THE SCHOLD FARM IN CLEAR CREEK VALLEY. Wheat has been grown in western Washington since the mid-1800s for three reasons: as a secondary cash crop, as a rotation crop to break disease cycles with other primary crops, and as a cover crop to protect and improve soil quality.

SCHOLD FIELDS. This photograph shows rows of lettuce as well as rows of corn (on the left side of the image). Second-growth timber on the hillside behind the house replaced the old-growth forests harvested decades earlier. The large building in upper center is the original Clear Creek School, remodeled into a home for Albin and Jean Schold. The buildings on the right are the John Holm house and barn, now known as the Petersen Farm.

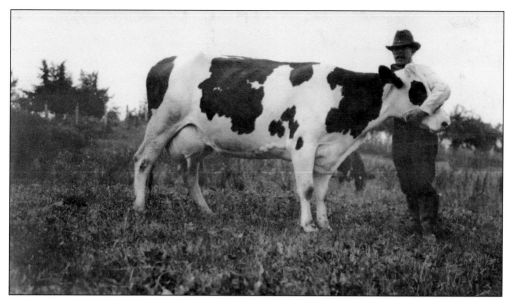

Prize Holstein. Albin Schold, owner of Meadowlark Dairy, shows one of his prize Holstein milk cows around 1920. In the 1880s, Albin's father, Andrew, and a neighbor, John Levin, needed cows for their homesteads. The two men walked to the town of Elma, Washington, purchased the cows, and led them home on foot—a round-trip distance of over 140 miles—thus starting the area's dairy business.

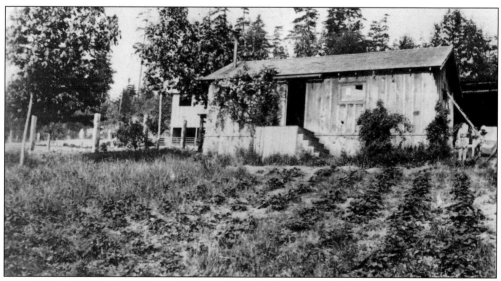

Bartlett Chicken Brooder House. This, the first home on the Bartlett property, became the chicken brooder when Marcus Bartlett built the main house near the bay. The brooder housed 500 baby chicks at a time. Strawberries flourish in the field in the foreground. This property was located on the east side of Clear Creek and the south side of Bucklin Hill Road. (Courtesy Barbara Bartlett Flieder.)

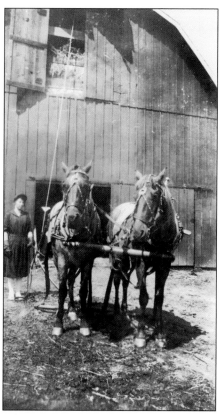

NELS NELSON FARM, CENTRAL VALLEY. With the help of one of his daughter Nettie and their horses, Dick and Prince, Nelson lifted 30-foot-tall stacks of hay into the second-story loft of the barn by using a grappling hook. Putting up hay was hot, dirty, lung-clogging work. A cow can eat 30 pounds of hay per day, requiring up to 2.5 tons of hay per cow to get a herd through the winter. (Courtesy Marlene Brooks Hattrick.)

KITSAP COUNTY EXTENSION AGENT GEORGE WORDEN AND 4-H CREW. Overseen by the Kitsap County Extension Service, 4-H (Head, Heart, Hands, and Health) organizations develop life skills for rural youth aged 5 through 19. Here, a group prepares to take a load of salal, a plant native to the Pacific Northwest, to Seattle for sale to the floral industry. Salal was first harvested for the floral industry in the late 1940s.

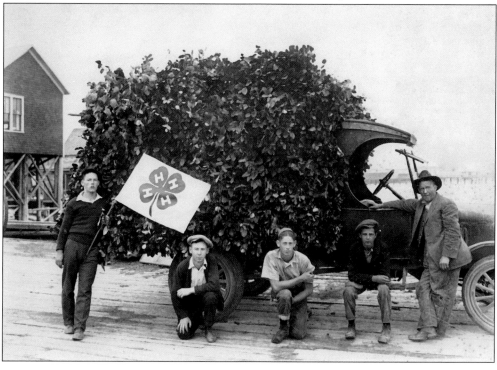

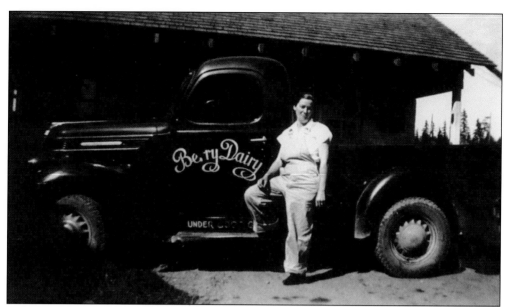

BERRY DAIRY. Ethel (pictured above with the Berry Dairy delivery truck) and Alfred Berry's dairy was on Mountain View Road at the north end of Clear Creek Valley. The letter (right) to Berry Dairy from the Dairy Products Show is for receiving a 98-plus score at the 1939 Western Washington Fair in Puyallup for its raw market milk. In the image, the bronze medal is shown at lower right; the disk used by the dairy to seal bottles is at lower left. (Both, courtesy Cindy Berry Starkenburg.)

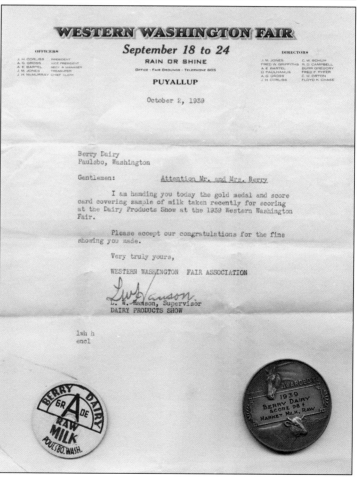

Holm Homestead, aka Petersen Farm. The barn was built by John Holm in 1904 and it remains unchanged. The house was constructed earlier, but it has been modified several times. Theodore Hilstad, brother-in-law of John Holm's daughter Sigurd, operated the 145-acre farm as Meadowlark Dairy for 31 years, selling to Gerald and Dorothy Petersen in 1948. A group of organizations and private citizens led by the Great Peninsula Conservancy purchased a 120-acre conservation easement along Clear Creek that runs through the property, allowing it to continue as farmland.

NORWEGIAN BALL AT THE CENTRAL VALLEY COMMUNITY CLUB FIELD. This form of baseball, called Norwegian ball because most of the settlers in Central Valley were Norwegian, was played with whatever equipment could be scrounged from materials at hand. In the image at right, it appears they are using a picket from the fence as a bat. Early forms of baseball played around North America were often referred to as "town ball." The image below shows spectators leaning against the Central Valley Community Club, which is still in use today by the Central Valley Garden Club. (Both, courtesy Marlene Brooks Hattrick.)

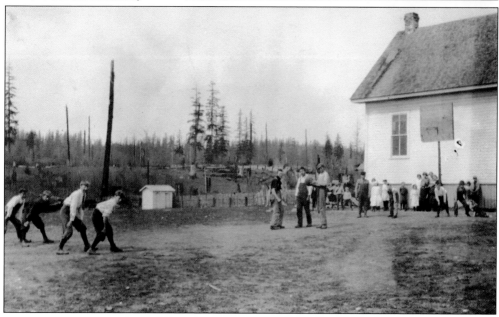

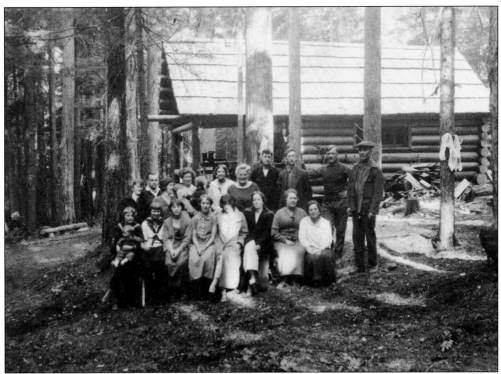

4-H Camp, Silver Springs. The Silver Springs campground was located on the north side of Mount Rainier. Sponsored by Kitsap County agricultural agent George Worden, this log lodge hosted 4-H members and their leaders and families.

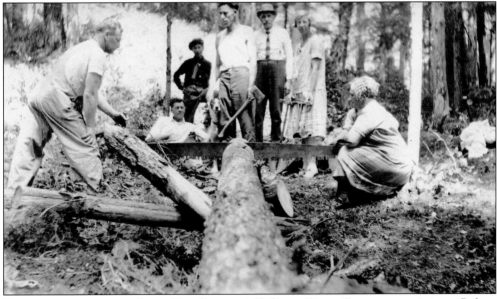

Demonstration of the Cross-Cut Saw at 4-H Camp. Kitsap County commissioner Robert Eben Bucklin and his wife, Hattie, of Bainbridge Island demonstrate the proper technique for the use of the cross-cut saw, with Mrs. Bucklin seated and wearing a dress. Western-style saws are designed to cut on the pull stroke and require minimal training to be used safely.

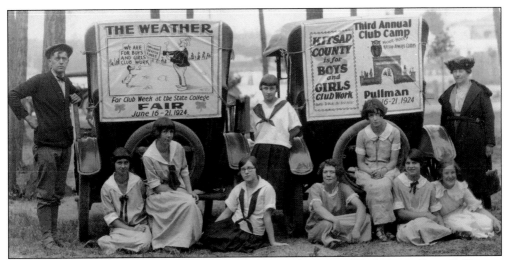

THIRD ANNUAL BOYS AND GIRLS CLUB CAMP. This took place at Washington State College in Pullman during the week of June 16 through 21, 1924, with the *Seattle Times* sponsoring it. These eight girls set out with their chaperones in two cars sporting banners that include their motto: "To make the best better."

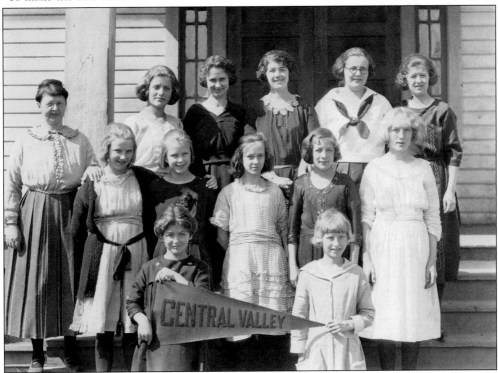

CENTRAL VALLEY 4-H CLUB NO. 9. Led by volunteers, 4-H classes taught young women a broad variety of skills that were useful in rural areas. Pictured are, from left to right, (first row) Agnes Ringness Berg and Mabel Olson Fairfield; (second row) Thora Fosberg Poincet, Anna Hanson Carter, Josephine Dahl, Ruth Ringness Olson, and Olga Olson; (third row) Pauline Dahl (leader), Martha Olson Auestad, Edna Dahl, Gina Ringness Anderson, Hilma Kippo, and Alice Ringness Johnson.

HALLOWEEN PARTIERS, 1930s. Costume parties have long been a form of fellowship and entertainment in rural communities. This Silverdale Methodist Church gathering includes, in no particular order, Marion Creelman, George Allen, Bill Greaves, Mary Allen, Mildred Wallace, Bob Swackhamer, Emma Linn, Edith Swackhamer, Reverend Cross, Vida Greaves, Dr. Ernest Creelman, Dorothy Swackhamer, and Grace Creelman.

CONRAD AND OLGA PETERSON'S NEW HOME, 1929. Located on Clear Creek Road, the Peterson home was one of the stops on a home and garden tour. These tours were often sponsored by local garden clubs to raise funds for community beautification projects. In addition to his work as a chicken and vegetable farmer, Conrad served as a machinist at the Navy yard.

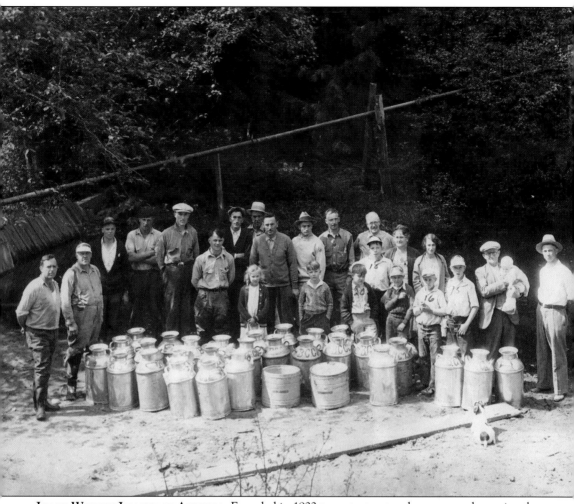

Izaak Walton League of America. Founded in 1922 to protect natural resources, the national organization has a powerful network of over 250 chapters. Lou Lent, of Bremerton, started the Silverdale chapter in 1928. Strawberry Creek ran through town and contained hundreds of salmon that migrated up the creek to spawn. That run had been reduced to a trickle, and one of the chapter's first endeavors was to curb the use of salmon traps, which were decimating the salmon population in Dyes Inlet by taking 20 times as many fish as needed. In this image, club members are using milk containers to transport the salmon fry. Pictured in the 1930s are Bill Greaves Sr., Stonecutter Anderson, Bill Dane, Victor Lindberg, Jim Kilkenny, Joe Hammer, Bob Robbins, Max Bartlett, David Bell, Fritz Carlson, Charles Wallace, Mildred Wallace, Barbara Wallace, Jimmy Kilkenny Jr., Andrew Anderson Jr., Everett Frost, Henry Peck (with baby), Joe Kilkenny, Robert Wright, and Don Hammer.

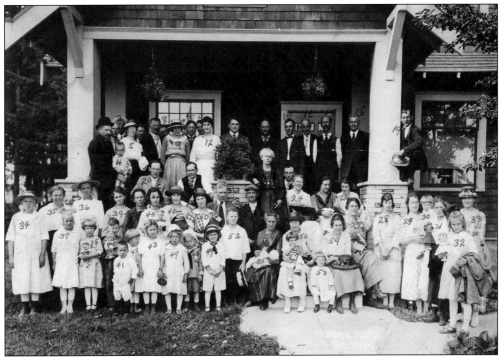

GATHERING AT BOB AND MABEL ROBBINS' HOME. Pictured are Jacob Ruef, Andrew Schold, ? Fisher, Della Thomas, Charles Greaves, Rasmus Qualheim, Frank Bourg (21), Sibyl Gakin McDonald (27), Grace Mill holding Billie Mill (29), Phyllis Bartlett (31), ? Hagener (32), Johanna Qualheim (33), Myrtle Paulson (34), Mrs. Pete Paulson (35), Doris Paulson (36), Ruth Paulson (37), Alice Waage (38), Anna Louise Waage (39), Matilde Alsted (43), Nancy Alsted (47), Alsted (48), Arnold Thomas (49), Myrton Thomas (52), Cora Gakin (54), Mattie Benbennick (56), Vernice McDonald (57).

JACKSON HALL, AKA BOY SCOUT HALL. Through a bequest by Jackson Hall, Works Progress Administration (WPA) workers completed the two-story log building on Washington Avenue, in 1937. It has been used by Boy Scout Troop 1552, Girl Scouts, Rainbow Girls, dance clubs, churches, and the Izaak Walton League of America; it also served as headquarters for an antiaircraft battalion, with a gun battery on Newberry Hill and barrage balloons throughout the area, guarding the Silverdale docks and oil storage tanks in World War II.

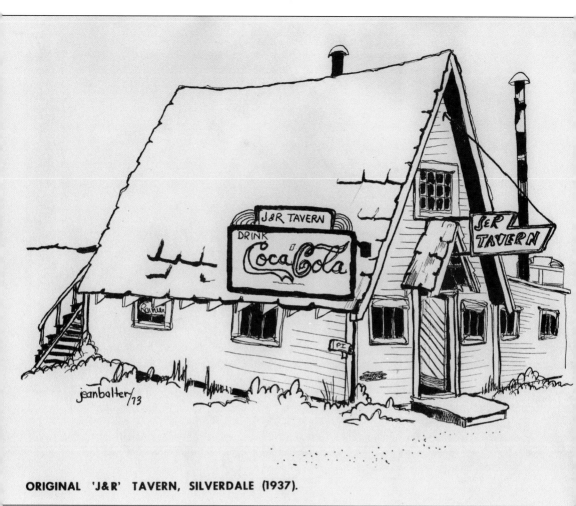

ORIGINAL 'J&R' TAVERN, SILVERDALE (1937).

J&R TAVERN. This drawing, done in 1973 by Jean Balter, shows the chalet-style building that was the first of three homes for the tavern. A sign on the wall of the tavern, which was owned by Rick Stonebridge and Jimmy Domstead, proclaimed: "Location of the J&R Tavern, 1/2 way between San Francisco and Anchorage, Alaska, on the left side of the road." A concrete block building was erected beside the tavern, which was torn down when the building was completed. (Courtesy Jean Balter.)

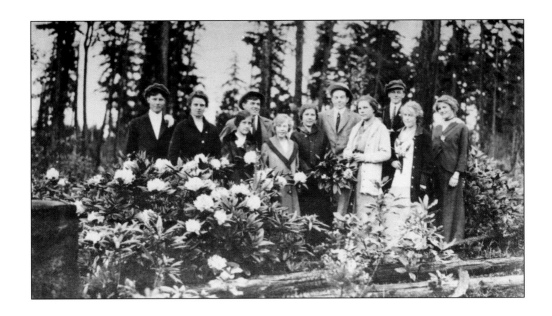

RHODODENDRON TOURS. For many years in the early 20th century, Kitsap County residents hiked or boated to Silverdale and Chico to gather the state flower. It took nearly all day to travel through the Port Washington Narrows and into Dyes Inlet, then hike to the woods to gather bunches to take home. In 1937, the first annual Rhododendron Tour began as a statewide campaign under the auspices of The Olypicans, Inc., a nonprofit organization based in Olympia. The goal was to promote the Rhododendron Tours on a national level and get 183,000 people from out of state to participate in the tours in a two-month period. Below, the Benbennick family's launch brings tourists to the rhododendron areas.

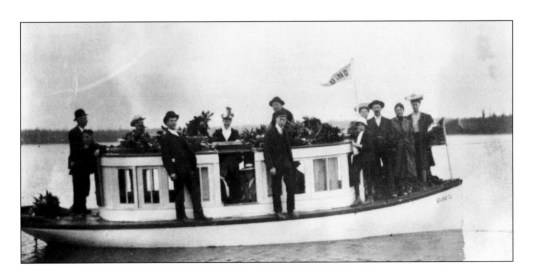

Gordon and Evelyn Berry, late 1920s. Gordon and Evelyn are shown on the dairy farm of their parents, Alfred and Ethel Berry, at the north end of Clear Creek Valley. Evelyn awaits her turn on the homemade cart. (Courtesy Cindy Berry Starkenburg.)

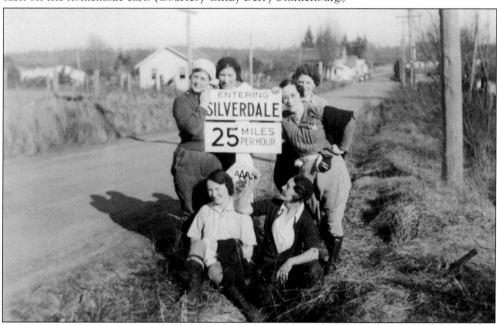

Bremerton's Klahanie Walking Club. *Klahanie* is Chinook Jargon (a trade language) for "outdoors." The club was comprised of 10 young women who hiked 10 to 16 miles each Wednesday from one end of Kitsap County to the other; they hiked year-round from 1934 to 1937. The founding members were Henrietta McCarty, Edna Thompson, Bonnie Davis, Nora Strong, Dorothy Maxwell, Billie Martin, Sue Manser, Stacia Brown, Bernice Acton, and Lois Davis.

YAMASHITA OYSTER AND STRAWBERRY FARM, 1944. Takuji Yamashita, born in Japan in 1874, started an oyster and strawberry farm on the east side of the head of Dyes Inlet. By the early 1940s, it was turning into a profitable business, and a series of sheds, houses, and a barge were visible to area residents. Before starting the oyster farm, Yamashita had owned a hotel and café in Bremerton. Yamashita was a member of the second graduating class of the University of Washington Law School in 1902. He passed the bar exam but was denied admission to the bar because it was required that he be an American citizen, and Japanese nationals were denied US citizenship. In 1941, the Yamashita family was among 70 Japanese families from Silverdale, Poulsbo, and Kingston who were sent to internment camps, and the farm reverted to the bank. (Both, courtesy Joan Guilford Kaiser.)

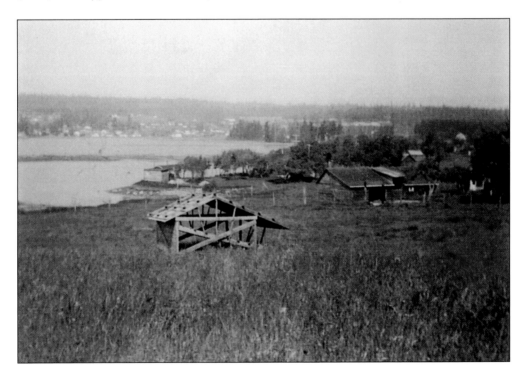

Three

NEW TOWN
1946–1989

Silverdale has experienced several dramatic changes in its economic base over the last century. The timber products, agriculture, and eggs that were once the primary economic activities gave way to defense-related industries during World War II. The nearby Keyport Naval Torpedo Station and Bangor Ammunition Depot remained important defense installations in the postwar era. Nothing, however, prepared the town for the expansion that occurred when Bangor, just to the northwest of Silverdale, was chosen as the West Coast port for the US Navy's Ohio-class submarines and its Trident missiles. Roads became freeways and the remaining forest lands became housing developments as more than $100 million in federal funds flowed into the community. Upgrades in the water and sewer systems, along with an expanded school system and public library, accommodated the population growth that came along with the new military base. The improvements in infrastructure allowed the town to grow once again. A retail corridor filled the former farmlands that lay between the old highway and the new freeway system. Both sides of the old Silverdale Way provided space for numerous strip malls, hotels, and restaurants. Centrally located Silverdale became the shopping area for all of Kitsap County. Silverdale retains its small-town character despite its evolution from small waterside community to major retail center. A spirit of volunteerism and pride in place manifests itself in the area's parks, walking trails, and community events. Many retired military personnel, attracted by the quality of life and the friendliness of the community, return to live in the area.

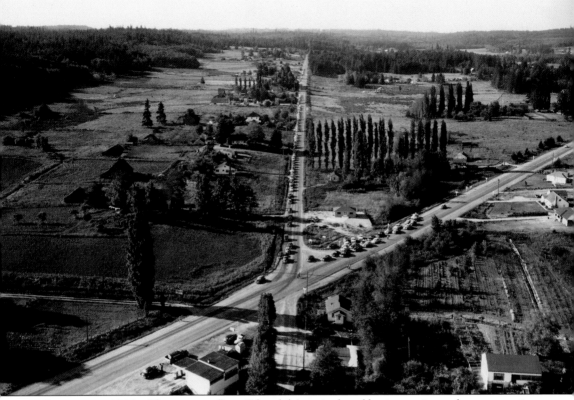

SILVERDALE, 1940s. This image reflects Silverdale's agricultural heritage prior to the construction of a large shopping mall, strip malls, freeways, and other commercial enterprises. The vertical road is Clear Creek Road. The cross street is Silverdale Way, once called Highway 21. The building at lower left in the image is the Flying A gas station located in the point of a triangle created by the convergence of both roads and Bucklin Hill Road (not shown). Poplar trees mark the southern boundary of the Greaves' farm.

SILVERDALE VOLUNTEER FIRE DEPARTMENT. After the volunteer fire department was created in 1942 by special election, Charles Snedicor was elected the first fire commissioner. The image above shows a 1936 Chevrolet half-ton flatbed, a 1942 Chevrolet fire truck, and a 1947 Mack fire truck in front of the first fire station. The old station was torn down in 1956, and an open house was held in 1957 in the new station, located next door at 9004 Washington Avenue. The SVFD held an open house for Christmas in 1962 to show off the station's second-floor addition (shown in the image below), which contained a large community meeting hall. The SVFD Auxiliary was formed to raise money using many means—weekly Friday game nights, dances at the Boy Scout Hall, spaghetti dinners, quilt and afghan raffles, pancake breakfasts, and door-to-door campaigning. The women also responded to daytime alarms when the men were working. (Below, courtesy Burt Boyd.)

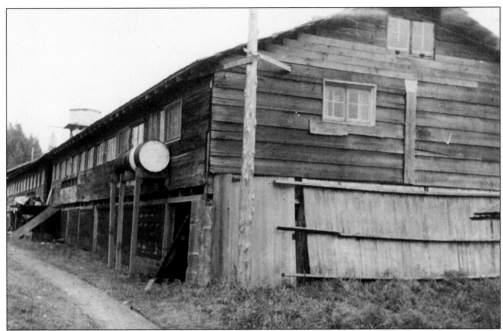

CHICKEN COOP APARTMENT. In 1941, the beginning of World War II ended Jim Guilford's job as agent for Albers Milling Company, as there could be no commercial travelers due to gas rationing. There was a large influx of people to the area to support the war effort. After purchasing Ed Troske's feed store and farm at the top of Bucklin Hill, the Guilfords converted the back half of the feed store, a former chicken house, into a fine apartment with kitchen cabinets from Montgomery Ward, an electric range, hot water, plaid ruffles on the windows, and a bathroom at the other end of the building. (Both, courtesy Joan Guilford Kaiser.)

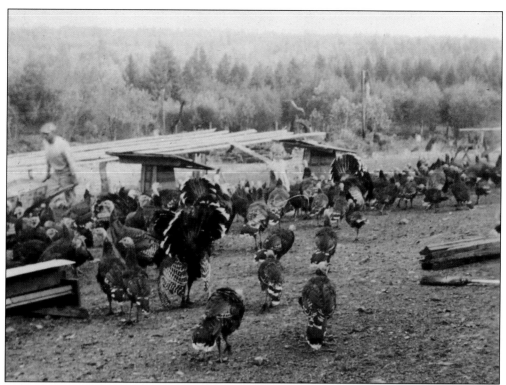

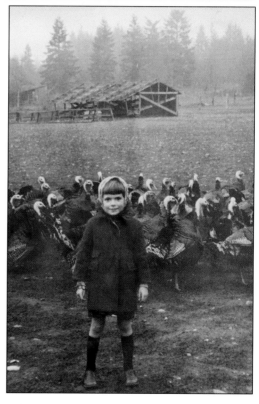

TURKEY FARM. In addition to running the feed store, Jim Guilford raised turkeys. In the image above, he goes about the many chores involved in that endeavor. In the image at right, his daughter, Joan, visits the turkeys—it appears they are as big as she. One drawback to the location at the top of Bucklin Hill was the limited amount of water available to serve the growing population of the neighborhood. In the summer, this made raising poultry problematic and was a contributing factor in Guilford moving his business to Silverdale and buying the Yamashita strawberry farm and oyster beds in 1943. (Both, courtesy Joan Guilford Kaiser.)

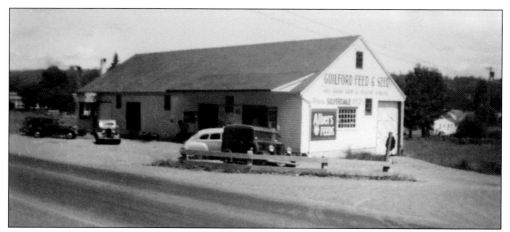

GUILFORD FEED AND SEED. James Guilford built this store in 1946 on the corner of Byron Street and Highway 21 (Silverdale Way). The new store also housed George and Zoë Harrison's *Silverdale Breeze*, a weekly newspaper that revived Thomas Haynes's defunct publication, and, later, Pederson's Appliances. After Guilford's death in 1957, the business changed hands several times, operating as Pope Feed & Seed, Benny's Barn, and Farmland Feed. (Courtesy Joan Guilford Kaiser.)

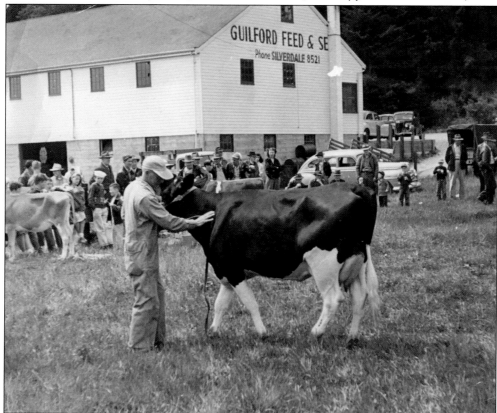

JIM GUILFORD'S "SPRING SHOW." The Spring Show, held every year in the field behind the store, prepared 4-H members and other area youth to show their livestock at the Kitsap County Fair in the fall. Guilford taught them how to present animals and themselves to a judge for the best advantage, and trophies were presented to the winners. (Courtesy Joan Guilford Kaiser.)

RAY M. HESS MEMORIAL LIBRARY. When countywide library service began in 1945, the Silverdale library, staffed by volunteers, moved from the basement of the Methodist church next door to the 16-foot-by-16-foot surplus World War II chaplain's office. The building's size was doubled in 1959 and enlarged again in 1970 and 1980. Hess was part of the second expansion effort and was an inspiration to others. (Courtesy Burt Boyd.)

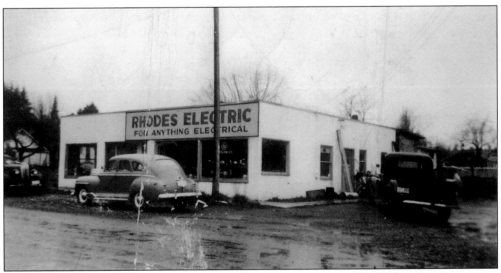

RHODES ELECTRIC, 1958. Jack and Alberta Rhodes built and operated this contracting business on the northwest corner of Byron and McConnell Streets. Being community-minded, Jack installed the field lights for Central Kitsap's Huey Field for free. The Rhodes also owned and operated Rhodes Appliance Center on Highway 21. Alberta taught school at Silverdale Elementary. This building has housed a multitude of businesses. (Courtesy Webb Rhodes.)

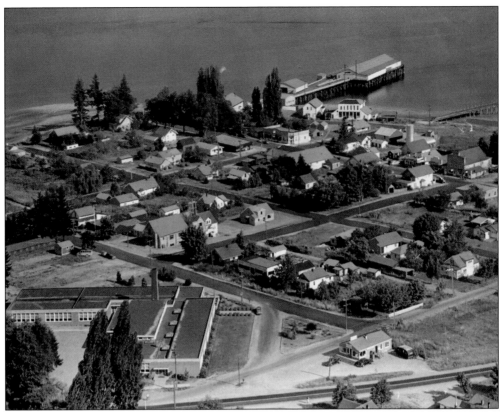

AERIAL VIEW OF SILVERDALE LOOKING EAST, C. 1946. A sparsely populated Silverdale is shown between Silverdale Way and Dyes Inlet. Silverdale Elementary is in the lower left corner, and the post office is across the street. The Washington Cooperative Egg and Poultry Association dock juts out into the water in front of the venerable Linn Hotel—the large white building just inland from the dock.

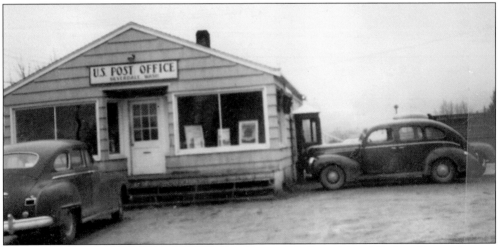

US POST OFFICE, LATE 1940s. Located on the corner of Highway 21 and Carlton Street, this was the first dedicated building used as a Silverdale post office. In 1962, when postal services moved north to 9468 Silverdale Way NW, this building became the XXX Drive-In.

SILVERDALE NURSERY, 1946. From the 1930s until 1948, Fred Roberts operated the Silverdale Nursery and Florist Shop at the northwest corner of the intersection of Highway 21 and Bucklin Hill Road. Roberts, an expert florist, is shown with his 1941 GMC pickup truck in the photograph below. After Roberts's death in 1948, his business was purchased by Edith and Red Jones. Roberts had previously owned the White Light Tavern (pictured above), a landmark in Silverdale until road improvements eliminated it from the triangle where Silverdale Way and Bucklin Hill meet. (Above, courtesy Burt Boyd.)

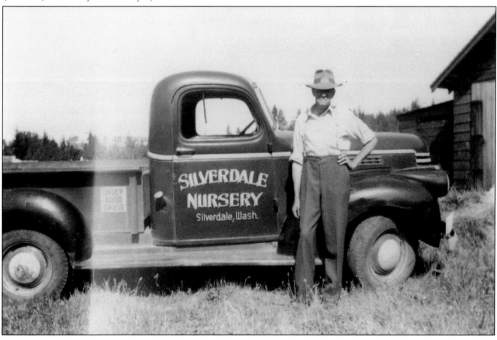

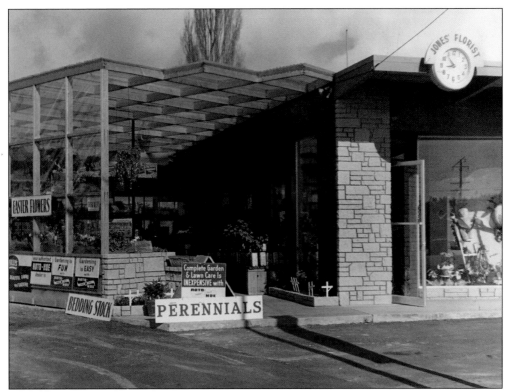

Jones' Florist and Nursery. Edith and Jesse "Red" Jones held a grand opening for their rebuilt store in December 1957. The new structure had a green Mediterranean brick front and windows angled to facilitate effective display and minimize glare. The greenhouse was located behind the building.

Hay Rake. Early mechanized hay rakes are called dump rakes. As the rake was drawn by horse or mule (later by tractor) across recently mowed fields, the operator sat in the central seat and used levers to periodically lift the tines to create parallel windrows. Once dried, the rows of hay were loaded onto wagons and stored in barns for the winter. Some rakes are still on display as field art in rural areas.

APEX AIRPARK, 1947. Ralph Walker (pictured) and his wife, Elizabeth, began the airpark in 1946 by bulldozing the original gravel runway. Located near Anderson Hill Road, it is a public-use airport and is considered a rural essential airport by the state. In the late 1960s, housing lots were developed on the west side of the airport. In 1981, the homeowners' association paved the runway and later installed lighting and a parallel taxiing turnout.

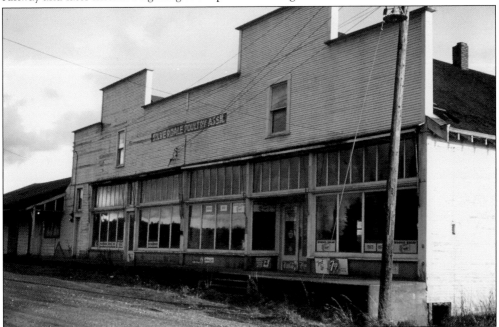

SILVERDALE POULTRY ASSOCIATION. The old building stands empty and derelict on the Silverdale waterfront after the cooperative moved to its new facility on Highway 21 in 1954. Tom Haynes, editor of the *Silverdale Breeze*, reported in 1932 that "the principal industry in the community is poultry and dairying. In normal times, more than $50,000 worth of these products are shipped from here each month."

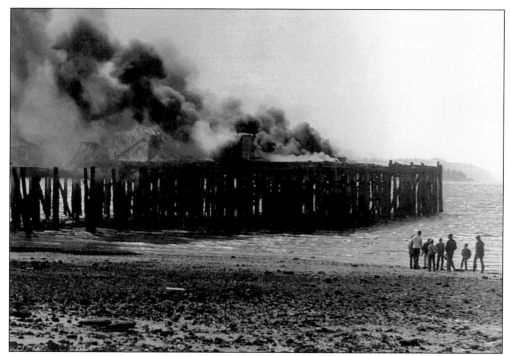

SILVERDALE COOPERATIVE DOCK BEING BURNED. The Port of Silverdale removed the "attractive nuisance" to make way for a new boat launch and park on August 24, 1969. Anticipated to take one day, it burned for two weeks, removing a favorite local youth hangout. Port Commissioner Harry Knapp then led the charge to remove unnecessary pilings and turn the waterfront into what it is today.

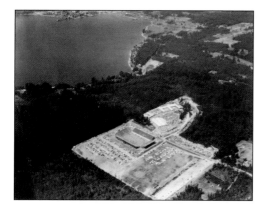

KITSAP COUNTY FAIR. Silverdale is visible in the distance in this aerial photograph. The first recorded Kitsap County Fair was held in 1923 in Port Orchard. In 1958, it was moved 15 miles to its current location in Central Kitsap. In 1929, exhibitors at the fair totaled 1,000; today, there are more than 6,000, with annual attendance of 80,000. In 1960, the Chief Kitsap Stampede sold stock certificates for $1 and constructed the Thunderbird Arena. Today, the arena is used for various events and has an annual overall attendance rate of more than 211,000.

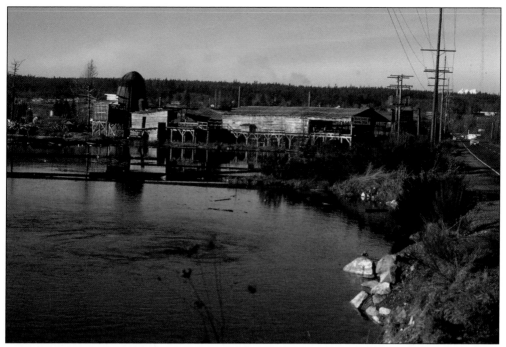

EDWIN J. SCHNEEBECK'S MILL. Around 1895, this site became the Westfall-Schneebeck Lumber Company. After a major fire event in 1958, the burner was disassembled. Today, only the 1950s Wehrhahn reciprocating saw, made in Delmenhorst, Germany, remains. The saw equipment can still be seen at the Old Mill Park at 2901 Bucklin Hill Road. (Courtesy Burt Boyd.)

RAY DARLING'S SAWMILL, 1947. Located at Fairview on the beach at Darling Road, this sawmill, which specialized in commercial and custom sawing, operated as D&M Lumber Co. from 1936 to 1946 and then reverted to Ray Darling from 1946 to 1953; Darling sold it in 1955. Darling retired from the Central Kitsap School District as head of facilities.

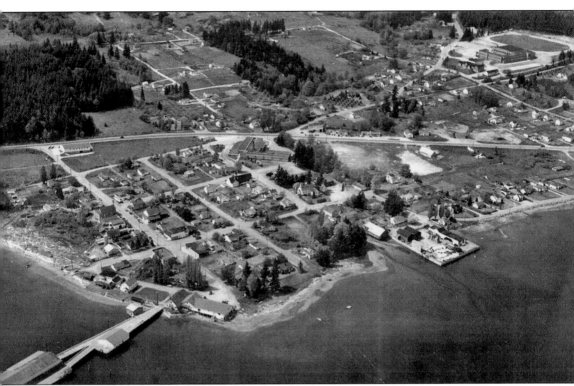

SILVERDALE AERIAL VIEW, 1952. Central Kitsap High School and Huey Field are behind and to the right of the old Port Washington Bay Union High School building in the upper part of the photograph. Guilford's Feed Store and the US post office are located on Highway 21 (now Silverdale Way) that bisects the image left to right.

Silverdale Male Chorus. From 1944 through 1952, Silverdale boasted a men's chorus, which performed at many public events in the area. Pictured are, from left to right, George Hoyt Sr., Leonard Clee, Claude Snitzler, Lloyd Thompson, Chancellor Walworth, director Brad Nichols, piano accompanist Geraldine Barnhill, Rodney Challman, Carl Jenne, Laurence Anderson, Thorton S. Devault Jr., Thorton S. Devault Sr., and "Doc" Matthews.

Bowling Team. A local lumber company, Dahl & Peterson, started in 1946 by Ole and Olaf Dahl and Roy Peterson, sponsored this bowling team. Pictured are, from left to right, (first row) Ray Brown and Red Jones; (second row) Bob Bowen, unidentified, and John Schold.

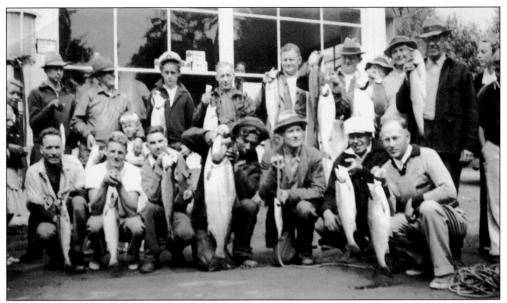

FISHING DERBY, C. 1950. These were once a popular form of recreation throughout the Puget Sound area. These participants are displaying their catches in a salmon-fishing derby conducted in Dyes Inlet. The two gentlemen fourth and fifth from the left in the first row appear to have caught the largest and smallest fish of the day, respectively.

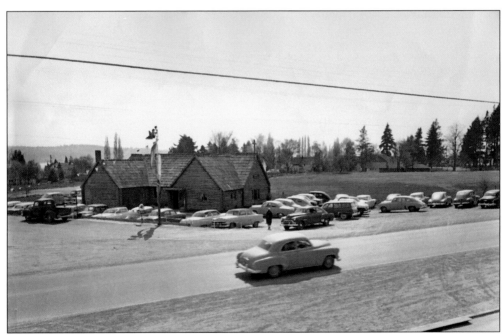

SILVERDALE LUTHERAN CHURCH, 1954. The church was established in 1949 with 88 members in the original "Log Cabin Church" on Highway 21 (now Silverdale Way). Although it was a charming building, it had its share of problems, and by 1959, a new church was dedicated two blocks north on Silverdale Way. The log cabin building is now home to Our Place Pub. (Courtesy Silverdale Lutheran Church.)

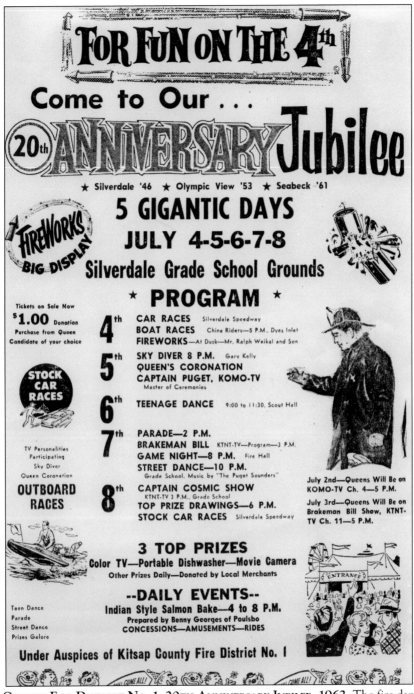

KITSAP COUNTY FIRE DISTRICT NO. 1, 20TH ANNIVERSARY JUBILEE, 1962. The fire department began as Silverdale's Volunteer Fire Department continually held fundraising extravaganzas. This jubilee included five days of festivities, with a parade, games, dances, prizes, KOMO-TVs Captain Puget and Brakeman Bill, Captain Cosmic from KTNT-TV, fireworks, barrage balloons, races, skydiving, daily salmon bakes prepared by Benny George's family of the Suquamish and S'Klallam tribes, and more. (Courtesy Claudia Hunt.)

Kitsap County Auto Racing Association

Presents
1974
Racing
Season

AT

Silverdale Speedway

Presented by K.C.A.R.A. Auxiliary

NOTICE: Auto racing can be dangerous—parts from cars have been known to fly into the crowds. We have made it as safe as possible but cannot be responsible for any injuries sustained by a spectator.

KITSAP COUNTY AUTO RACING ASSOCIATION PROGRAM, SILVERDALE SPEEDWAY. The 1974 season program, presented by the KCARA Auxiliary, cost all of 50¢, up from the 25¢ charged a few years earlier before organization under the KCARA. The trade-off was greater safety, despite the warning on the bottom of the program—"parts from cars have been known to fly into the crowds." (Courtesy Cordell and Bonnie Sunkel.)

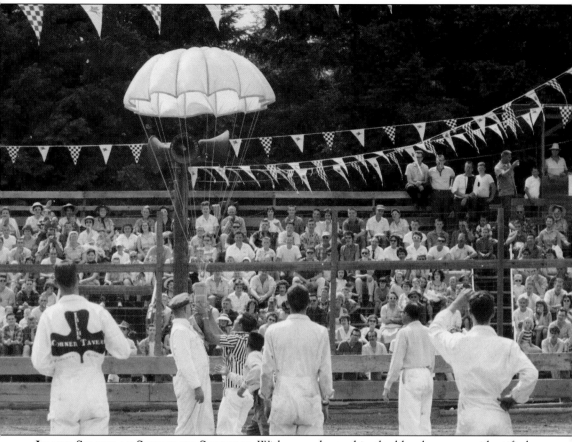

IN THE STANDS AT SILVERDALE SPEEDWAY. With a good crowd in the bleachers, an unidentified package is caught by a race judge as it parachutes onto the racetrack as part of the opening festivities. The pit crew from Poulsbo's Irish's Corner Tavern watches. (Courtesy Bob Gossett.)

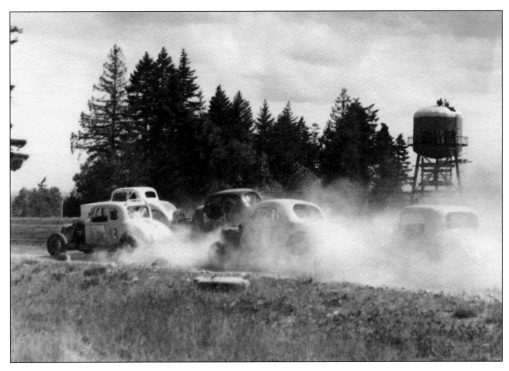

FIRST TURN AT SILVERDALE RACETRACK. In the mid-1950s photograph above, which was taken just after the green flag, Robert "Bob" Gossett is driving No. 13, a 1933 Pontiac he called the "poor man's Bonneville." (Both, courtesy Bob Gossett.)

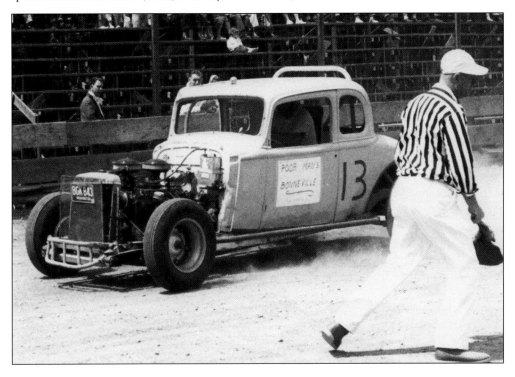

MEMORIAL DAY CEREMONY, LATE 1950s. Silverdale's Henry Bryner VFW Post 4992 held yearly ceremonies honoring the nation's war dead at the World War I Memorial to Henry Johnson in front of Silverdale Elementary School. In the image below, L.D. Serena, past commander and life member of VFW Post 4992, is in the center. In the image at right, a local Campfire troop joins in the ceremony; Karen Serena is the girl at far right. (Both, courtesy Cordell and Bonnie Sunkel.)

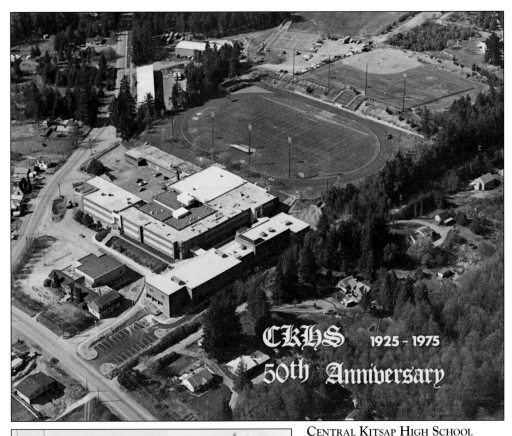

CKHS 1925 - 1975
50th Anniversary

CENTRAL KITSAP HIGH SCHOOL 50TH ANNIVERSARY, 1975. The contrast between the 1924–1925 Port Washington Bay Union High School, located in the lower-left corner of the above photograph (just above Bucklin Hill Road), and the sprawling campus that the new school now occupies is dramatic. Likewise, the farming community has morphed into the commercial center for the Kitsap Peninsula. At Central Kitsap High School, 43 percent of the students' families are either active-duty military or other Department of Defense employees. The old high school served as Central Kitsap District Administration offices until it was replaced by the Jenne-Wright Building. At left is a view of Bucklin Hill Road looking east from in front of the high school. (Both, courtesy Cordell and Bonnie Sunkel.)

SILVERDALE STATE BANK INTERIOR AND VAULT DOOR. After moving from Old Town to Silverdale Way in 1976, the bank purchased the cooperative store's remaining building. Extensive remodeling resulted in the bank at 9490 Silverdale Way NW, which is shown in the photograph above. Since the old vault remained in the previous building, a new, larger vault was installed. Silverdale Antiques purchased this building in 2007, and the vault remains there today. (Both, courtesy Burt Boyd.)

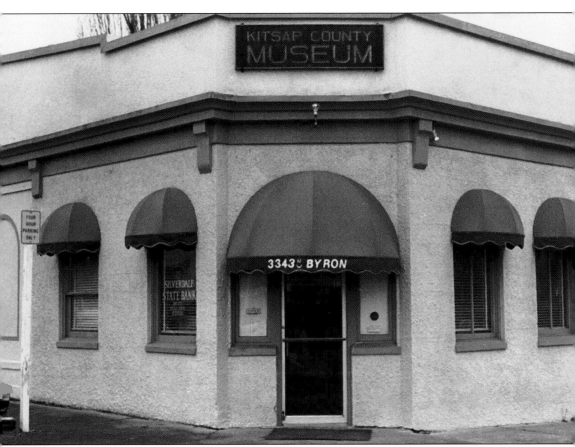

KITSAP COUNTY HISTORICAL SOCIETY MUSEUM, 1976. The society started a museum in 1949 in two rooms at the Kitsap County Courthouse in Port Orchard. After operating for years in an old telephone building in Bremerton, the museum moved to this former Silverdale State Bank building in 1976. In 1995, the society purchased a larger building, the former Seattle First National Bank, at 280 Fourth Street in Bremerton. At that time, the former Silverdale State Bank building was sold and became a doctor's office.

Silverdale
WHALING DAYS
August 17 and 18

"Let's all whale in Silverdale"

**"You can help in many ways,
Just buy a button for Whaling Days"**

"Whaling Days" is for you, the people of Silverdale and Kitsap County, to enjoy. It's being brought to you by the Central Kitsap Chamber of Commerce, Silverdale Lions Club and the Silverdale Rotary Club. This year's "Whaling Days" is the first of an annual event to be held in Silverdale for your enjoyment at an unbelievably small expense.

Fifteen to twenty-five thousand persons are anticipated at this event with a two-and-a-half-hour air show, an eight-heat hydroplane race, a motorcycle race and a national open aquarium showing. These attractions are **FREE**. There will be a pancake breakfast and a two-day salmon bake. The parade on Saturday morning will be a giant attraction with special floats and personalities you won't want to miss.

☆ SATURDAY, AUG. 17 ☆

PARADE
10:00 A.M. — DOWNTOWN SILVERDALE
Featuring J. P. Patches thanks to Silverdale Thriftway
and The Scottiish Highland Bagpipe Marching Unit.
"See our Head Whaler — Let's hope he can sail 'er"
The Silverdale Lions Club

MOTORCYCLE RACES
1:00 P.M. — SILVERDALE SPEEDWAY
"Thrills galore — You'll be askin' for more"

SALMON BAKE
5:00 P.M. — OLD SILVERDALE WATERFRONT
"Complete Salmon Dinner that won't make you thinner"

STREET DANCE
9:00 P.M. — POPLARS PARKING AREA
Live Music and Lively Fun
"Pick up your feet right out in the street"

☆ SUNDAY, AUG. 18 ☆

PANCAKE BREAKFAST
8:00 A.M. 'TIL 11:00 A.M.
SILVERDALE VILLAGE PARKING AREA
"Fat, fluffy cakes with what ever it takes"
The Silverdale Rotary

AIR SHOW
11:00 A.M. — OLD SILVERDALE WATERFRONT
Motorcyclist soars off boat ramp at 80 m.p.h.
Fly-bys of antique and vintage aircraft
Airobatics by WWII Stearman & Pit Special
"They'll be goin' up, they'll be goin' down
And some might not even get off the ground"
Coast Guard On Duty!

HYDROPLANE RACES
1:00 P.M. — OLD SILVERDALE WATERFRONT
Eight Heats — Speeds up to 100 m.p.h.

"These boats are speedy, these boats are fast,
A thrill every minute as long as it lasts"

Coast Guard On Duty!

SALMON BAKE
1:00 P.M. — OLD SILVERDALE WATERFRONT
"Fresh Salmon that's tender, you'll never stay slender"

☆ SATURDAY & SUNDAY ☆

AQUARIUM SHOWING
CK MALL

"An exhibit of interest is yours without fail,
With all kinds of fishes, maybe even a whale"

SIDEWALK SHOPS
THROUGHOUT ENTIRE DOWNTOWN SILVERDALE
• Crafts from leather to wood carving • Terrariums
• "Applehead" people • Films of local marine environment • Refreshment Booths • Bingo
• Dunking Booth • Many More . . .
"Sidewalk Shops Supreme — Enjoyment Extreme"

☞ **SEE THE 40-FOOT WHALE** ☜
SILVERDALE—*"Thar's where she blows"*

Presented on behalf of The CK Chamber of Commerce
COMPLIMENTS: THE SILVERDALE PRINTER—692-5225—Gary & Trudy Bowlby

WHALING DAYS PROGRAM, 1977. "Let's all whale in Silverdale" was the theme of the first Whaling Days. In 1972, the notion for a community festival was hatched over coffee at Bogard's Drug lunch counter. Regulars around the lunch counter included Dr. Robert Gordon, Gary Bowlby, Ron Ross, Glenn Brooke, Terry Simon, and John Schold. The festival included a salmon bake, hydroplane races, an aquarium show, motorcycle races, an air show, and a street dance. The Silverdale Lions Club organized the first parade, and the Silverdale Rotary cooked up the first of many pancake breakfasts. The Central Kitsap Chamber of Commerce was instrumental in the organization of this annual festival, which started in 1975 and which is now run by an independent group of dedicated volunteers. (Courtesy Cordell and Bonnie Sunkel.)

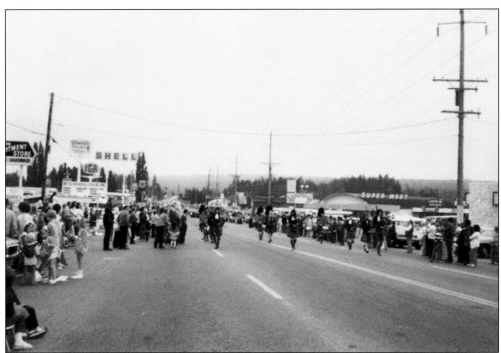

WHALING DAYS PARADE, AUGUST 17 AND 18, 1977. The parade, sponsored by the Silverdale Lions Club, began at 10:00 a.m. with the Scottish Highland Bagpipe Marching Unit leading the way. Traveling from Seattle to perform, this pipe band has been in existence since 1938. J.P. Patches was the featured television personality this day. Special floats and personalities were promised, and the unidentified young man below does not disappoint. His bike has been transformed into a baby whale complete with pacifier in its mouth. With crepe paper in the spokes and a special hat on his head, this young man could be proud of his float. (Both, courtesy Barry Isles.)

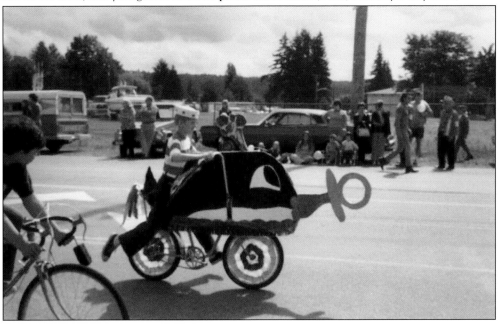

WHALING DAYS.
Silverdale's signature festival, Whaling Days, began as a family-oriented event run by volunteers and local civic groups. It was called Whaling Days after festival founders rejected a more appropriate chicken theme in favor of a bigger mascot. Wendy Whale, a 40-foot-by-12-foot-by 12-foot beauty wearing lipstick, was towed in the first Whaling Days parade. Northwest residents learn to expect rain; it rarely puts a damper on their fun. (Both, courtesy Cordell and Bonnie Sunkel.)

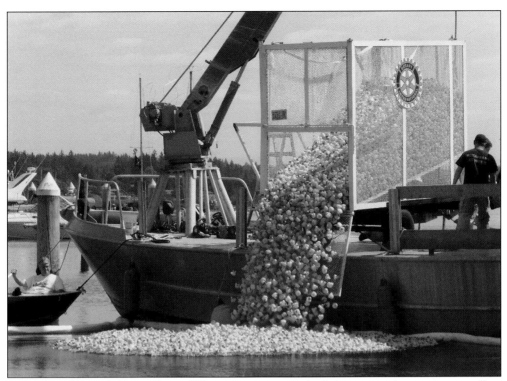

SILVERDALE ROTARY DUCK RACE. Where canoes once plied the waters there are now yellow plastic ducks. Starting in 1993, as part of each annual Whaling Days celebration, the Rotary Club of Silverdale sponsors a duck race on Dyes Inlet. In a spirit characteristic of Silverdale, local businesses donate substantial prizes, and residents throughout Kitsap County purchase tickets in the hope that "their" duck will win. Money from the ticket sales is used for community projects and scholarships. Above, the ducks enter the water and prepare to float into Dyes Inlet on the tide. Below, the first ducks enter the winner's chute. (Both, courtesy Rotary Club of Silverdale.)

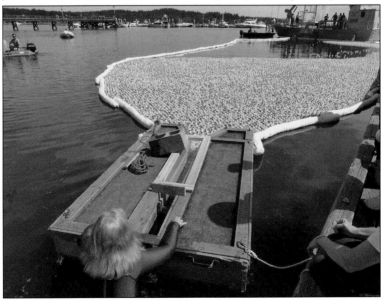

CO-OP SUPER MART

12026 Clear Creek Road NW SILVERDALE, WASHINGTON 98383 Phone 692-9957

TO OUR COMMON STOCKHOLDERS:

This letter will be the first contact the Board of Directors has had with the Common Stockholders since the membership voted to sell the store property back in 1965. As it turned out, the store was sold on contract rather than an outright sale, so therefore the accumulation of funds to redeem stockholder's equities has been somewhat slow. However, we are pleased to report that it made possible the payment of all outstanding bills, taxes, insurance and loans, followed in turn by the Preferred Stock issue of about $70,000. In addition we were able to honor the outstanding patronage dividends created in 1962.

At this time we are in a position to call in and redeem the Common Stock accounts, which number over 900. Since many of these certificates are as much as over 50 years old we are aware that locating them at this time would be somewhat difficult. However, we would like to receive back as many as reasonably possible, but if they cannot be located we are also prepared to make redemptions on the basis of signed affidavits. So if you are unable to locate the certificate with a reasonable search you may either write us or call, whichever is most convenient.

According to our records you own Common Stock Certificate #*335* for *10* shares, so will you please sign on the back side in the lower right hand corner and return to us.

Many of the addresses shown on our records are out of date, so therefore we would very much appreciate any help regarding addresses of any of your friends or relatives who own stock but for whom we do not have the correct address.

It seems that quite a few people did not receive their certificate at the time of purchase, but these were still here in the Co-op. files, and in those cases we are enclosing these certificate to be signed and returned for redemption.

Since many of the older stockholders are now deceased and the stock may now be held by their heirs, it will be necessary to submit some form of legal paper such as Letters Testamentary, copies of Wills, or something similar to clear payment to the heirs. We shall be glad to work with you on an individual basis to accomplish this.

It has taken a long time to make this final payment, and we have been very appreciative of the patience shown by our Stockholders, but at the same time it should be pointed out that Silverdale Co-op. is about the only Co-op. in this area that has redeemed 100% of membership equities as well as having paid the 6% dividend on the Preferred Stock during the years it was in process of being redeemed.

Sincerely yours,

SILVERDALE CO-OPERATIVE ASS'N.

Gerald Petersen
Board President

P.S. There are still some 1951 and 1962 Revolving Fund certificates outstanding, so if you have any of these please send them along and we will honor them at this time.

SILVERDALE COOPERATIVE ASSOCIATION COMMON STOCK CALL-IN. In an official marking of the end of the agricultural era in the Silverdale area, over 900 common stock accounts were called in and redeemed. The final physical building to house the cooperative, which began in 1915, was sold in 1965. This letter went out on June 7, 1982, and is signed by board president Gerald Petersen.

Kitsap Mall Dedication, August 1985. Kitsap County's retail core shifted from Bremerton to Silverdale when the Winmar Company, Seattle-based Safeco's real estate branch, built the Kitsap Mall. The original anchors were Lamonts, Sears, and Bon Marché. Later in the decade, the mall nearly doubled in size, adding new stores and expanding the existing stores in over 700,000 square feet of retail space. (Courtesy Burt Boyd.)

1989
"A Full Year Of Centennial Events"

JOIN IN THE FUN
Local News Media Will Keep You Informed

Calendar Of Events:

April 13th	Silverdale is 100 years old.
April 15th	Waterfront Festival to commemorate Silverdale's Centennial.
7:00—Noon	Lions Pancake Breakfast at Jackson (Scout) Hall.
10:00	Retrieval of time capsule of 1937 and burial of the 1989 capsule. A Guest Book, signed by attendees, will be inserted in the Capsule. Sponsored by **Silverdale State Bank**. Guest of Honor: **Ralph Monroe, Secretary of State**. **Center Stage** presents a skit from **"The Quilters"**.
10–5:00	The **Kitsap County Historical Society Museum** will be open.
11:30	Dedication of the Murals. Three Murals in Old Silverdale. Sponsored by the **Silverdale Centennial Committee** and funded by the sale of **Centennial Coins** (see below).
11:30–3	Taking place on the Waterfront: The **Dandy Lions** will be serving Hamburgers and BBQ chicken. The **Silverdale Grange** will be demonstrating an authentic **Vintage Egg Cleaning Machine**. The **Centennial Committee** will sell all commemorative items.
1:00	The **Kitsap County Centennial and Historical Society** presents **"Lars, a Swedish immigrant cook"** discussing life in a 1910 logging camp. Jenne—Wright Gym (Old Silverdale Elementary).
1:00–3:00	Games for all ages sponsored by the **Dandy Lions**. There will be **many prizes!**
June 24th	Cruise on the **"Spirit of Seattle"**
6–9:00pm	Cruise departs from the Silverdale Dock and retraces the route of the Mosquito Fleet. Included are Hors d'oeurves, a no host bar, **entertainment**, and an auction of a Commemorative Silver Coin, number 001. Sponsored by the **Patrons of the Silverdale Chamber of Commerce**. Cost: $20.00
July 28th	Silverdale Post Office will hand cancel **cover envelopes with a centennial stamp** affixed. Kitsap Mall

Watch throughout the year for other events.

WE INVITE YOUR ORGANIZATION TO SPONSOR AN EVENT OR ACTIVITY!

Only 100 numbered Centennial Silver Coins were minted.
Purchase yours now while supplies last.
Contact Goldberg's Jewelers at Kitsap Place.
Phone: 692–1425

For more info, contact the Silverdale Chamber of Commerce
at 692–6800 or Jennie Cooley at 692–5538.

CENTENNIAL CALENDAR OF EVENTS, 1989. Commemorative events began in April with a waterfront festival starting with a pancake breakfast, followed by the retrieval of the 1937 time capsule with guest of honor Secretary of State Ralph Munro. (Courtesy Cordell and Bonnie Sunkel.)

FARMLAND CENTENNIAL MURAL. Three murals were painted in Old Town Silverdale in 1989, and one is on the end of the Farmland Pet Store building. Another, painted on the Silverdale Port Commission building on Byron Street, shows Earl Peterson in overalls holding a chicken. The third mural no longer exists. It was of an old Mosquito Fleet steamship at the pier and was painted on a wall of the Kitsap County Historical Society Museum building (the old Silverdale Bank building) that was in Waterfront Park.

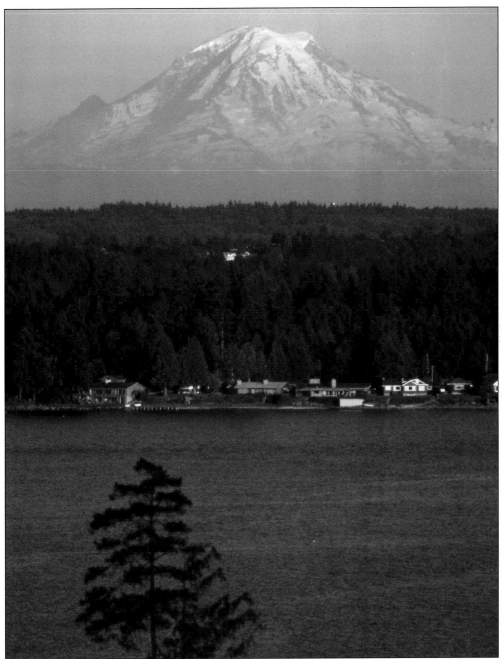

MOUNT RAINIER OVER DYES INLET. On February 21, 1929, editor Tom Haynes waxed poetic in his *Silverdale Breeze*: "Port Washington Bay (Dyes Inlet), at Silverdale's front door, an inlet of Puget Sound, measuring some five miles wide and seven miles long, lying like a gigantic diamond in an emerald setting which on moonlit nights, when the surface is riffled by soft zephyrs, converts itself into millions of glittering gems, millions of sparkling sapphires—the most gorgeous thing imaginable." With the magnificence of Mount Rainier—all 14,411 feet of it—rising as a backdrop to Dyes Inlet, it is a wonder that Haynes did not acknowledge the existence of another gem complementing the object of his admiration. (Courtesy Burt Boyd.)

Discover Thousands of Local History Books
Featuring Millions of Vintage Images

Arcadia Publishing, the leading local history publisher in the United States, is committed to making history accessible and meaningful through publishing books that celebrate and preserve the heritage of America's people and places.

Find more books like this at
www.arcadiapublishing.com

Search for your hometown history, your old stomping grounds, and even your favorite sports team.